JAY BOY

THE EARLY YEARS OF JAY ADAMS

KENT SHERWOOD

Introduction by C. R. Stecyk III
Foreword by Tony Alva
Essay by Glen E. Friedman

UNIVERSE

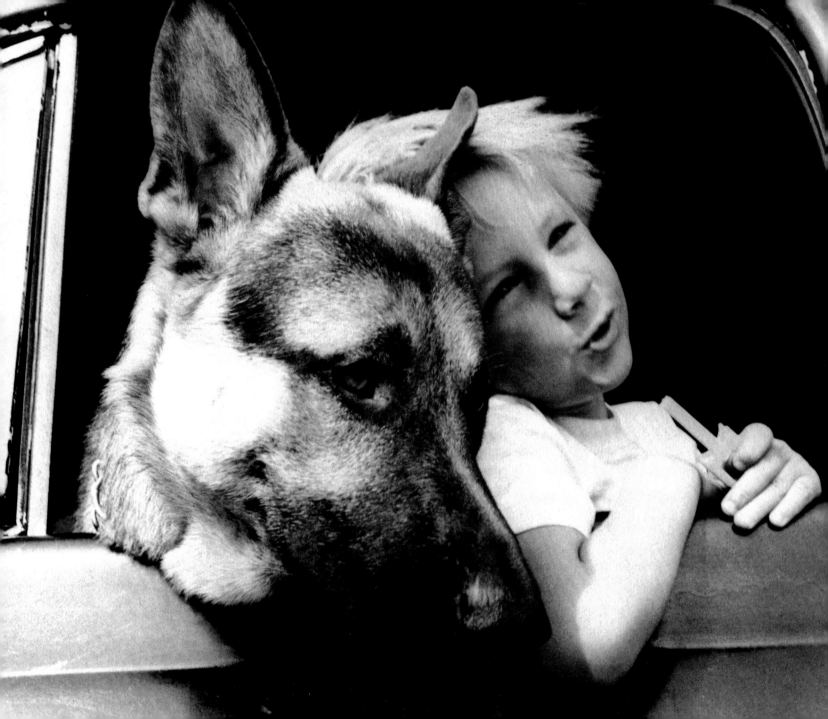

The dog's name was Beastie, he was my first dog that I remember.
I remember Kent and my mom told me Kodak was interested in using
this photo for something but I guess they never did.

EA'S BEACH RENTALS
WE RENT SURFBOARDS

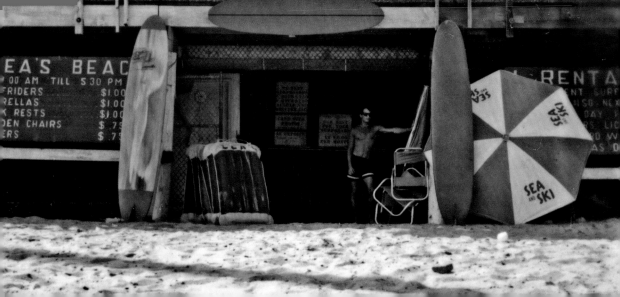

INTRODUCTION
BY C. R. STECYK III

Jay Adams is a member of the Skateboarding Hall of Fame, listed in *The Encyclopedia of Surfing*, and was the lead subject of two highly acclaimed films, the documentary film *Dogtown and Z Boys* and the theatrical release *Lords of Dogtown*. His death was covered by a myriad of mainstream outlets including *The New York Times*, Vice, *The Washington Post*, *US* magazine, *The Los Angeles Times*, *The New York Daily News*, *The Daily Mail* UK, Juice, CNN, *The Mirror* UK, MTV, *Thrasher*, *Surfer* magazine, *Surfing* magazine, *The Skateboard Mag*, the *Times of San Diego*, TMZ, X-Games, United Press International, *Los Angeles* magazine, ESPN, *The Hollywood Reporter*, *The O.C. Register*, and the *Franchise Herald*. His legend is virally contexted, which constitutes immortality in this day and age.

Kent Sherwood is retired and resides in Malibu. He holds a number of patents for pioneering achievements in composite material construction techniques. As many of these innovations involve advanced technology and are deemed to be of militarily strategic importance, they are highly classified. Despite his tremendous success Kent remains the same unassuming Honolulu beach boy I met decades ago in Dave Sweet's surf shop.

For that matter, Jay never changed much either. He radiated the same superlative stoke for surfing and skateboarding that he honed at Sherwood's rental stand underneath Pacific Ocean Park Pier on every day of his life. In the end Jay Adams was a marine minister and concrete crusader to the end. A true 100 percenter.

Jay passed away on August 15, 2014 from a heart attack, which occurred while he was on a surfing trip with his wife, Tracy and his boyhood friends Alan Sarlo and Solo Scott at Puerto Escondido in Oaxaca, Mexico. He was sober, devoted to his religious practice, and he had satisfied all of his legal obligations and was free to travel. Our subject was in fine spirits and performing athletically in his advanced extemporaneous manner. Along the way Adams had also forged significant relationships with his son Seven and his daughter Venice.

The following observations were written under a high voltage transmission tower that was located by the side of U.S. Interstate 5 in central California in 2006.

Down. Another seven to burn. Maybe looking. Twenty-five. To life. Saved by the blood of the lamb. Scorched by Hades on earth. For what? Jay Adams has always been the right guy in the wrong place. Far ahead of the auspicious time. Jay comes, gets off good and leaves before the official games begin. Clearing out and moving on through. Maybe not perfect but forgiven in the sense that Adams don't whine, he pays as he goes. Suckers pick his pocket but they can't touch his heart.

...coulda had a career. An Adams had to do was show up, take the money, turn fakey tricks and smile warm all fuzzy-like for the cameras. But he nevva wasted a moment on shit like that. From day zero J-Boy weren't gonna be no monkey in no show. Category: personality Type A for adaptability. A prisoner of politics. Absolute creativity threatens the drones of conformity. So every day brings another tax to be assessed upon those who travel on their own. In the circumstance of evidentiary love, Jay's got a new daughter named Venice who he's not really seen. Having been locked down during her birth. For the offense of not getting along by going along.

Known him since small kid time. Me and his stepdad Kent Sherwood worked out of the Dave Sweet surf shop in Santa Monica where polyurethane foam boards were invented. Philaine Romero would bring the child down at lunch and he'd pilot his skate out into the traffic on Olympic Boulevard.

Just riding on his knees. Not walking much yet. But already fast rollin' towards improvisational infinity.

Mom's gone now. His brother's been shot thoroughly dead too. Kent survives via getting contracts from the U.S. government to sculpt fine technological marvels out of composite materials. The politicians issue official proclamations that state Sherwood is a credit to us all. And maybe he is, cause he don't ever look at the awards. Just like his son Jay don't

watch the films. Of the legend he forged before which he cannot now care to remember.

People harp on Adams's undeniably pervasive influence and the perceived irony of missed opportunities. Jay has always been honest in the things that matter. Most often operating out of decent and selfless motive. Propelled by the impetus of initiative that provided a mandate for mayhem that occasionally led to shitting on the playgrounds of privilege.

These photographs reek of Sherwood's insider perspective back then as the armorer of choice for fun along the oceanfront. And of the kid's intrinsic role as the test pilot for sidewalk surfing's future. Forever in a day.

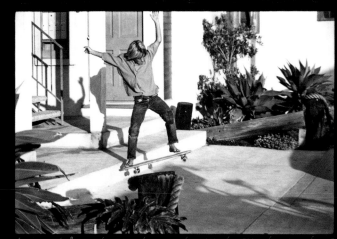

→ 35 → 35A

This is the front of the apartments next to the Shack. I learned this trick from the movie Skater Dater. At the time this was a pretty cool trick to know how to do, for a kid anyway. I also learned how to turn around and go back up and over that li'l curb. That's probably my

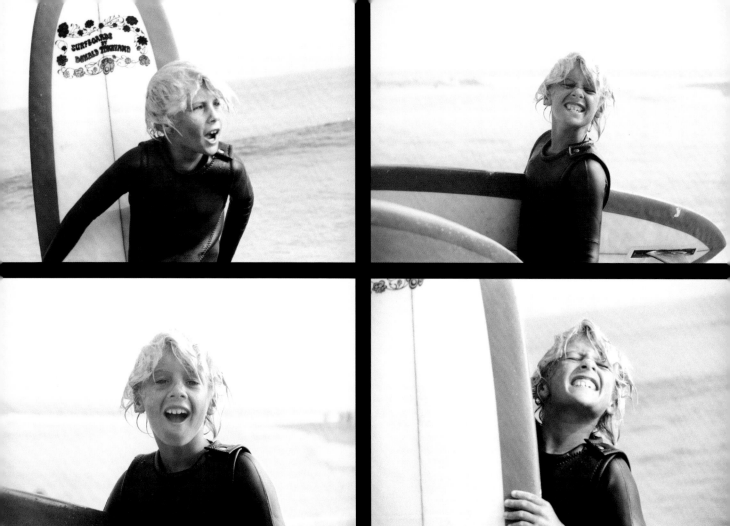

FOREWORD
BY TONY ALVA

I met Jay Adams when I was hitchhiking underneath the pier
in Santa Monica and Jay's mom Philaine pulled the car over
and gave us both a ride to surf Malibu. These photographs are
truly an intimate look into the innocent days of Jay's life before
anything happened for him in skating or surfing. Simply, a
super cute, blond-haired, blue-eyed surf kid who was stoked
to spend his days at the beach. The photographs that Kent took
show that. You can easily see it.

The weight of being a pro skateboarder wasn't here yet. Jay
never gravitated towards being famous. He just wanted to surf
and skate. He wanted to have fun and that is what attracted
me to him. He was already a great surfer and people wanted
a piece of that. As those things began to occur in his life,
Jay changed. You can see it in later photographs. He became
quick to anger and a lot more aggressive. These photographs
are of Jay Adams before life became complicated. They are
a time machine. A secret look back into the innocence of Jay
that few people ever saw. Angelic on the outside and a little
devil on the inside. When these photographs were taken,
Jay was ten steps ahead of all the other kids. He had it and
he kept it through his entire life.

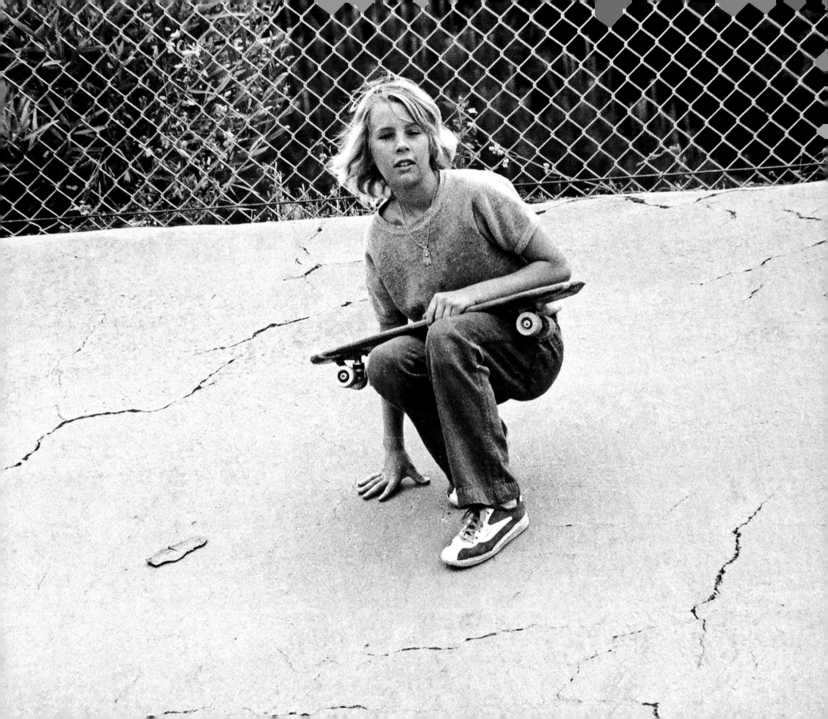

ESSAY
BY GLEN E. FRIEDMAN

This is a book of photographs of the legend as a boy, taken by his stepfather Kent Sherwood. Kent was my first and only hourly wage employer when I worked at the Z-Flex shack in Venice one summer as a teenager. These images are some rare, early moments of Jay, his friends, family, and his lifestyle, most taken before anyone like Craig Stecyk or myself made pictures of him.

Jay and I go back, way the fuck back. My first published photo was a full-page subscription ad for *SkateBoarder* magazine; Jay was the subject, and it was radical in more ways than one. I took the photo when I was fourteen and Jay, the belligerent "Radical Little Rat," was fifteen. Jay often remembered it as his first published photo, too—it actually wasn't, but he remembered it that way, which is very flattering. We were kids and we thought we knew everything, like most kids do. I found out about this pool near my local spot, the Kenter Canyon School yard, borrowed a 35mm camera, invited Jay and Paul Constantineau to come, and that's where the documented history of Jay and I started.

Over the years we would travel around the southern California basin to different skate spots, parties, and punk gigs. I've witnessed some pretty incredible shit around him, both positive and negative, he was a spirited one, that's for sure. Jay was no slouch; he often surprised me, and others, with his brilliance on and off his board. Even though he was one of the most out of control mother-fuckers, he would do something only an insane person would do, and then hit you with some "science" that would have you asking yourself, "Where the fuck did that come from?" Although he didn't always act like it, Jay was smart. He was no doubt one of my all-time favorite subjects to make photos with because of his aggressive style, his unpredictability, his vision.

He was the seed for so many—one of the originators and great revolutionaries—*and he didn't do any of it on purpose*. He was as spontaneous as they come. He was an inspiration to me and countless others of his generation, and generations to follow. Jay Boy's legacy will forever be unparalleled in the art/activity of skateboarding.

Jay was the personification of all the DogTown stories that Stecyk wrote, and all the DogTown photos that I took: all we were trying to do was capture Jay Adams's essence. He was the life-long wild child, and he was incredibly great at the same time. Kent's pictures of Jay are an advance peek, the test pressing—or the "demo" version—of the man Jay would become.

He *was* a living legend . . . and a crazy friend . . . and now that he's gone, we only have the memories. And for you all who didn't know him personally I am happy that we have the photographs to share. I suspect his legend will live on gloriously.

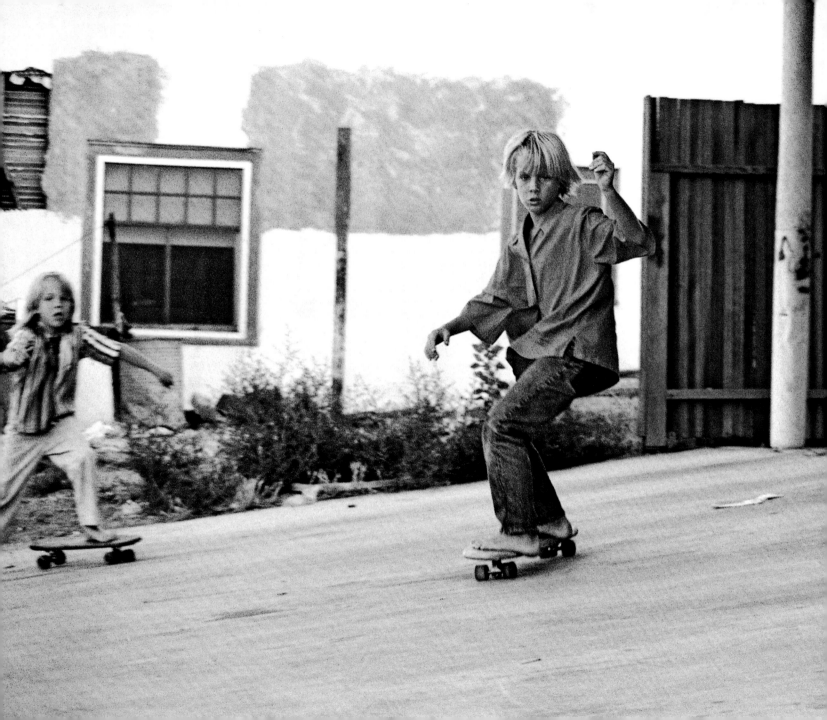

When I remember being a kid, this is one of the visions
that comes to mind. 9 or 10 years old riding a clay wheeled
Hobie skateboard barefoot. Total longboarder surf style.
This is the driveway next door to the Venice shack.

One of my oldest skate shots. Probably around 1969. Check
out the clay wheels. We used to skate there everyday.
Pretending that I was Wynne Lynch or Jeff Hackman.

When your mom is just your mom you never think of her as a hot chick. Now that I'm older than she is in the photo, I can see that Kent was a lucky guy. My mom was hot. Is that weird to say? This is the picture I have tattooed on my left arm.

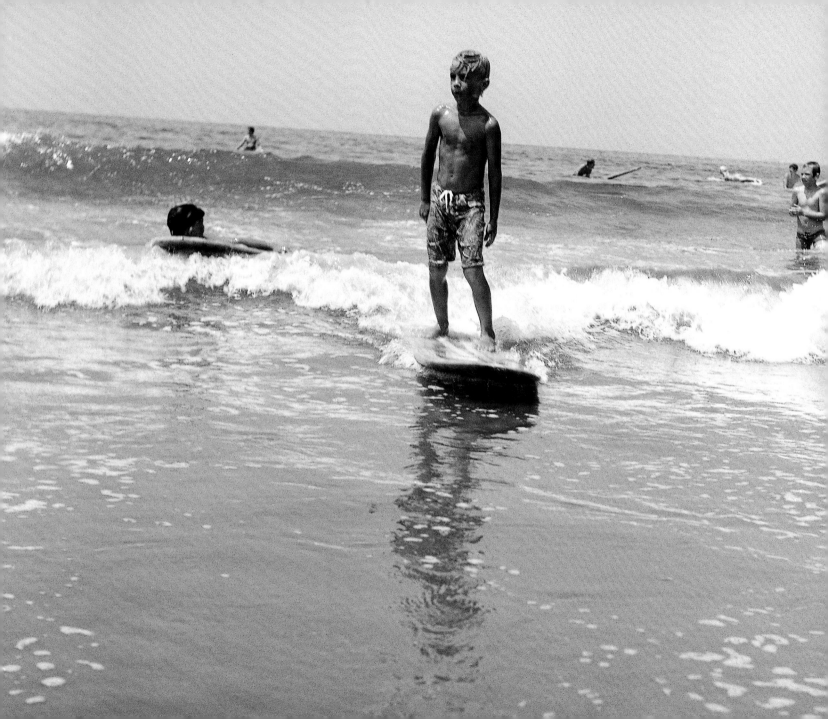

About 6 yrs old surfing in front of Kent's beach rental place at Pacific Ocean Park. They were just making the Santa Monica Towers across the street. Trams drove down the boardwalk from Venice to Santa Monica Pier. I used to love to hide behind trashcans and bomb the trams with rotten fruit or sneak up behind the Jewish men takin' a nap on the bench in front of their church and tip over their hats while they slept on the bench. They'd wake up and chase me down the boardwalk.

Scott Herman walking home from the Shack after going for a surf.
This shot is taken from our back porch. Scott lived two bridges over
in the Venice canals. Scott and I used to have a window breaking
club. We got caught after breaking about 7 or 8 windows down the alley
from our street to the school. Another time we were walking along
the canal across from his house. I bet him I could break his window
from where we were. He said no way, I broke his kitchen window on
the first try. The only problem was his sister was standing in the back
yard and saw us running away. Busted again.

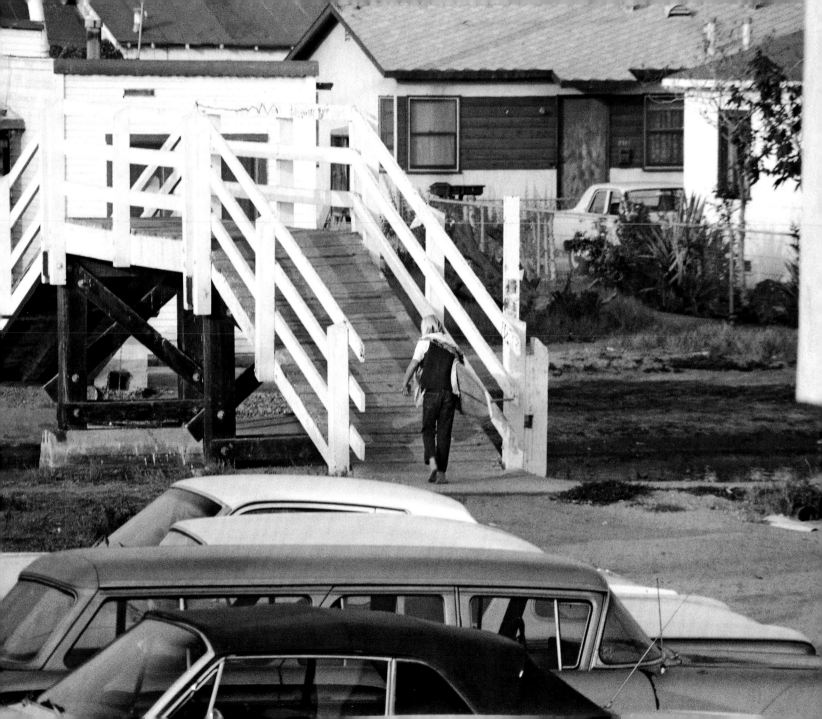

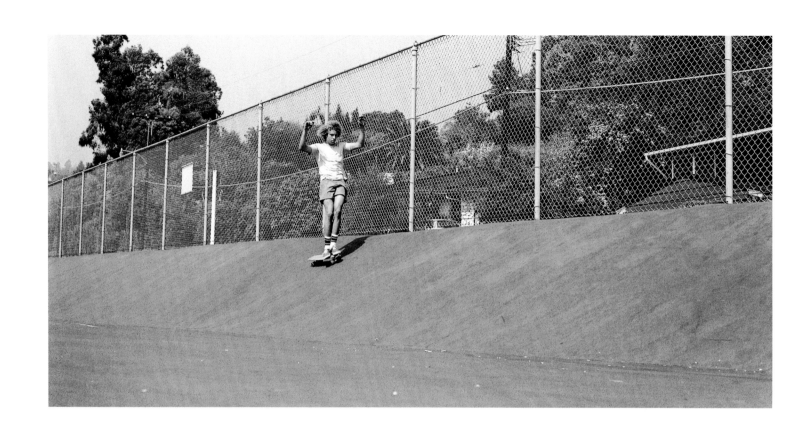

TONY ALVA
This is Alva at Kenter doing his famous cross step.
He's actually going pretty fast. I don't think I was at
Kenter this day because for one there's not photos of me
and two I just don't remember being there this day.

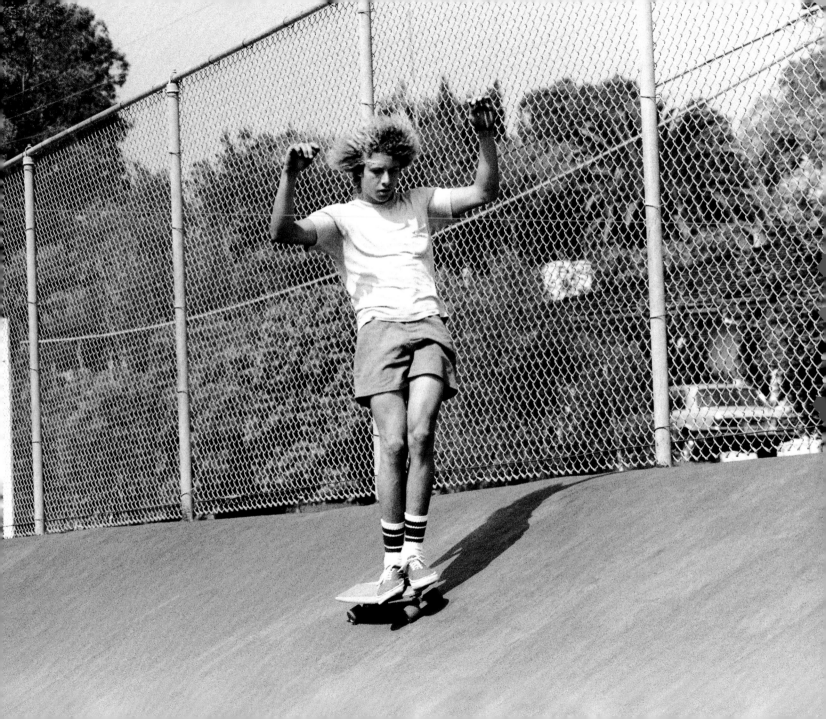

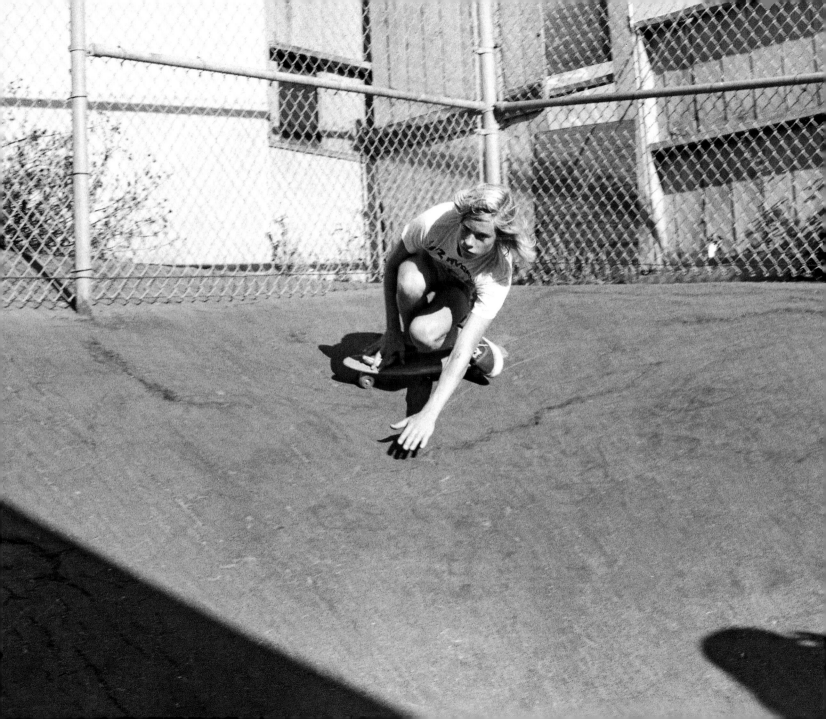

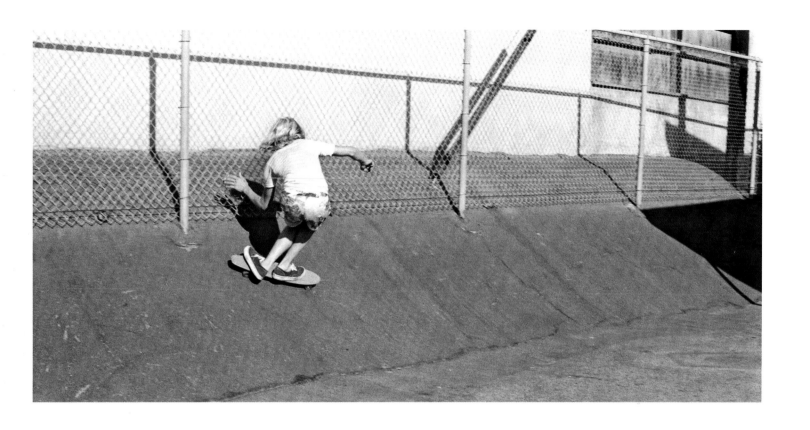

WENTZEL RUML IV

Wentzle surf skating at St. Clements school. I like how he's using the fence like a wave. It looks like he's got his EZ-Ryder shirt on. EZ-Ryder was before Z-Flex after Kent my mother and I broke away from Zephyr. Tony Alva, Shogo Kubo, Biniak, Baby Paul, myself and I think Marty Grimes were on EZ-Ryder. Muir, Peralta, PC, and few freestylers stayed with the Zephyr shop.

Just another day at Malibu. I remember Micky Dora
telling me he wanted to kidnap me and take me to France
to make a real surfer outta me.

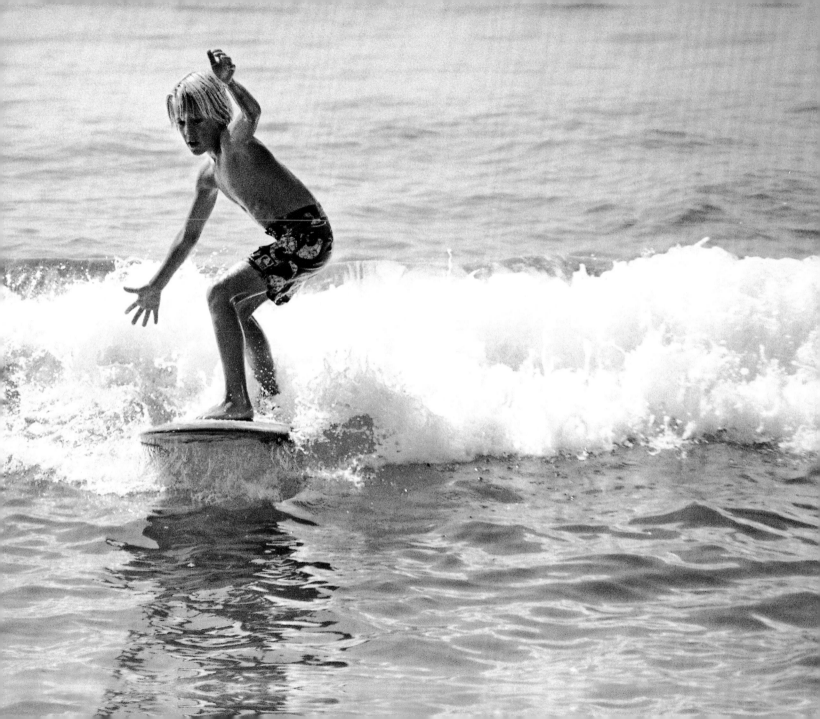

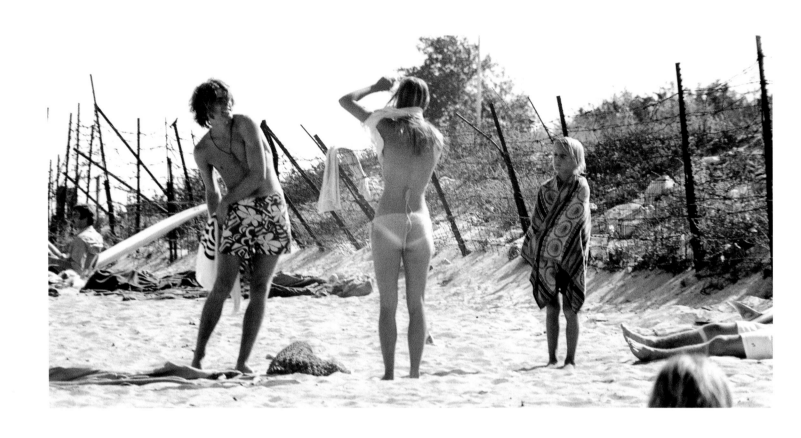

Dave White ruled Malibu when I was a lil kid. He adopted me as a lil
brother. Him and his friends would tell me to tell the girls "my friends
want to have an orgy with you guys." I didn't know what I was saying
but later on in life he told me I scored him plenty of hot chicks.

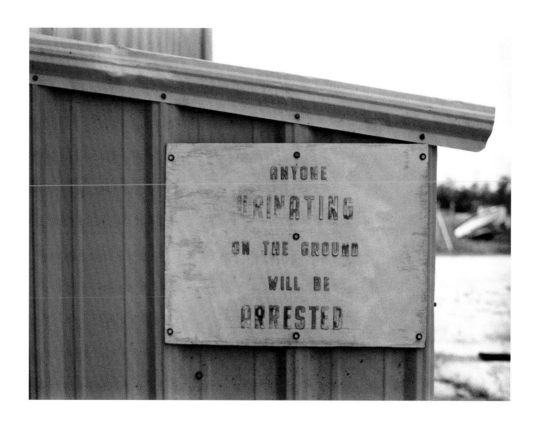

ANYONE
URINATING
ON THE GROUND
WILL BE
ARRESTED

Yeah right. Looks like a perfectly good toilet to me.

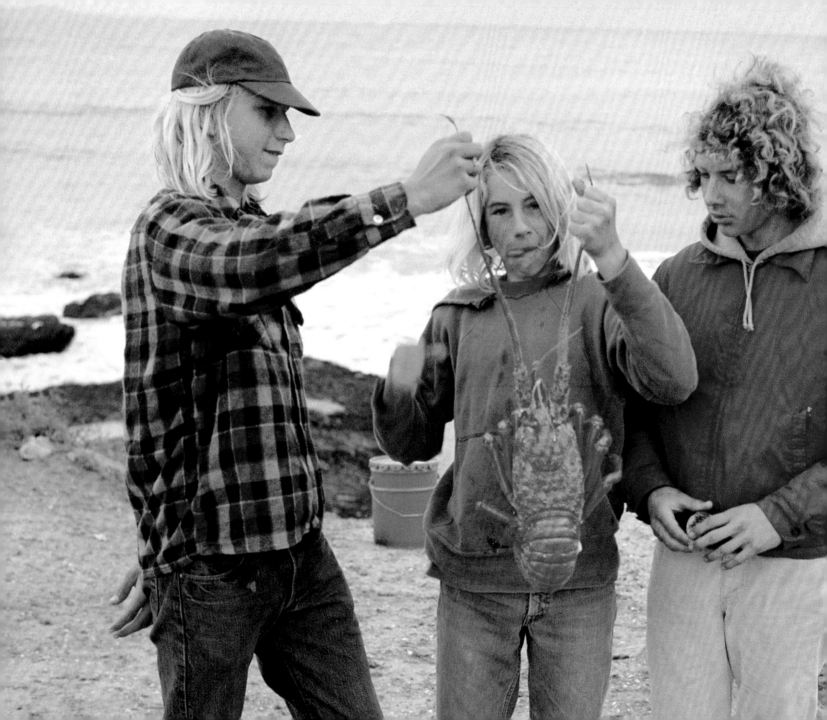

Down in Mexico with Alva and John Baum.
I kind like the dirty clothes that I have on. This was before
clothing companies were giving Tony and me free clothes.

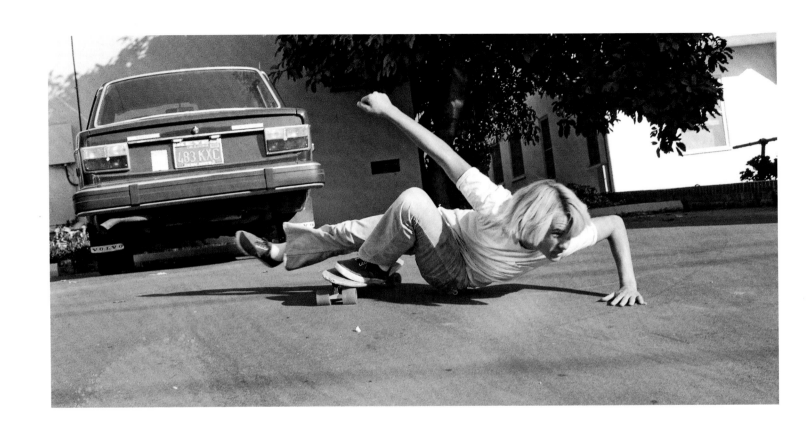

This is right down the alley from the Highland house in Santa Monica.
The magazines called it a christy I called 'em one-legged Berts. I think
I did those before the mags put their lame name to 'em Steve Cathy
got credit for doing 'em but I think I did 'em at the Del Mar contest
before. I really can't remember, but then, should I really care?

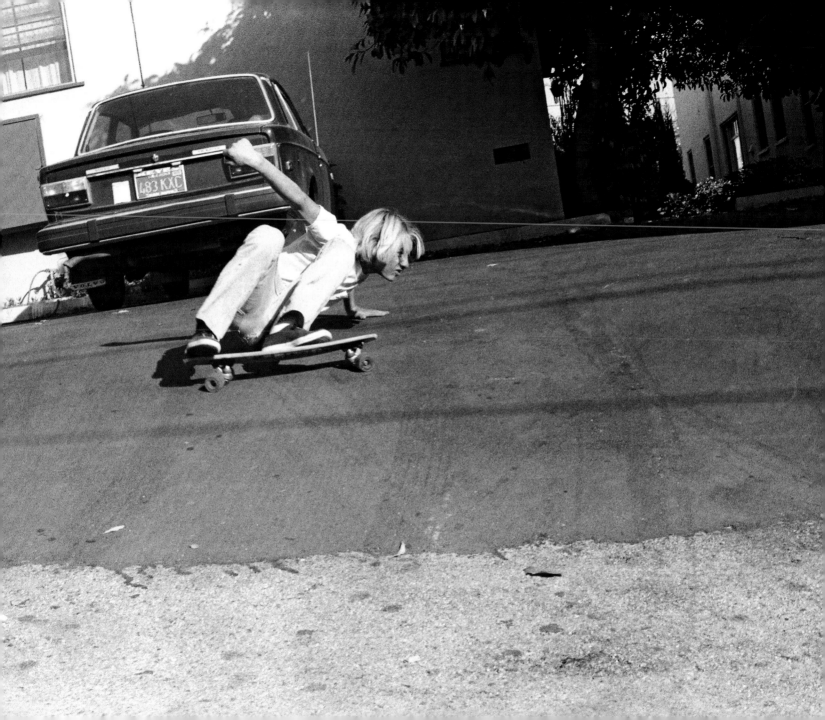

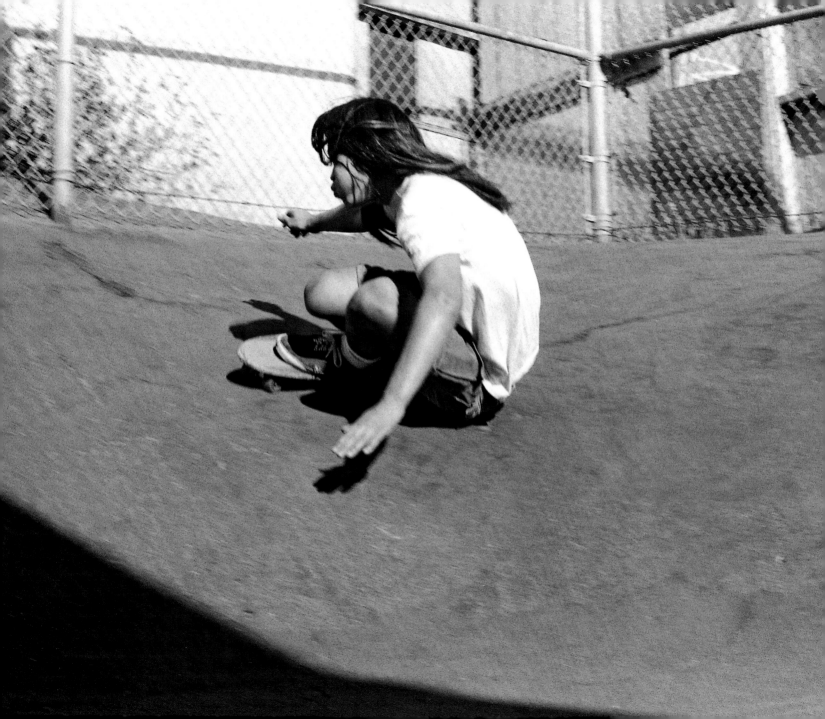

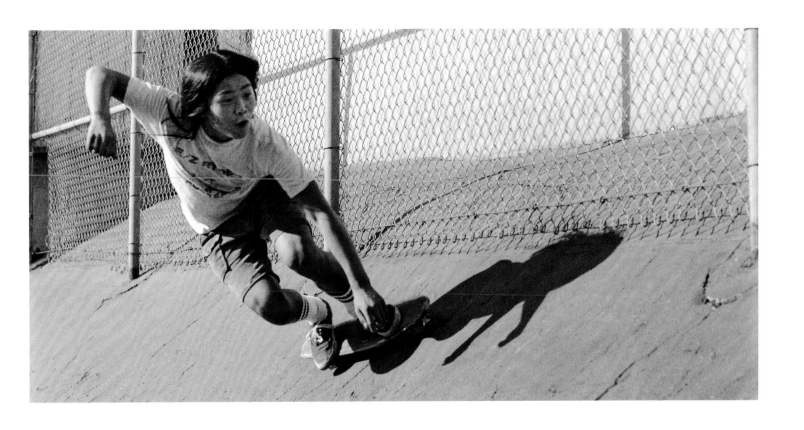

SHOGO KUBO

Shogo was all about style. There was a time when style actually
mattered. I met Shogo at the Judo school that Kent enrolled
me in. Judo was good for balance. I used to bring my skateboard
and skate on the basketball court before we went into class.

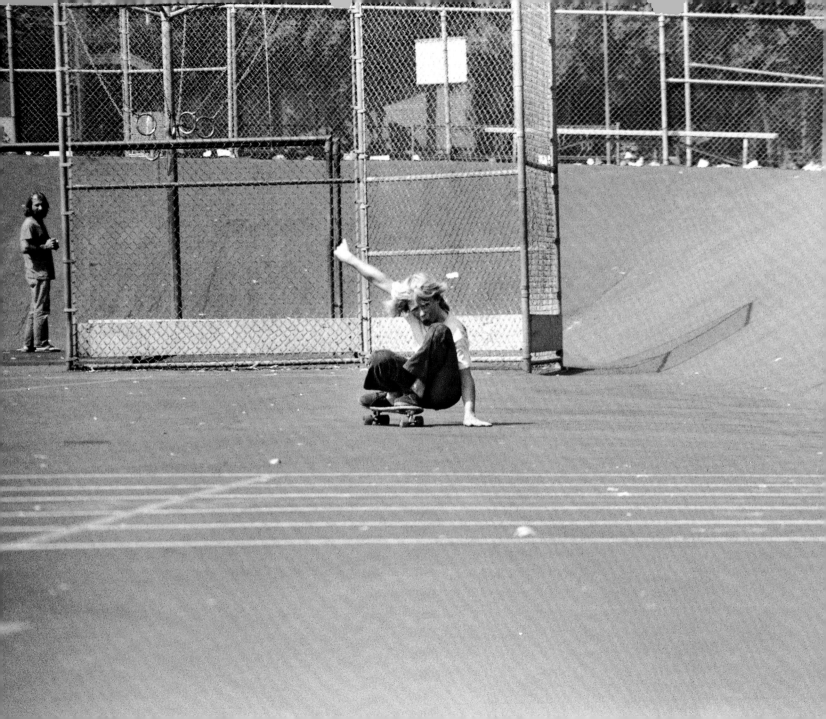

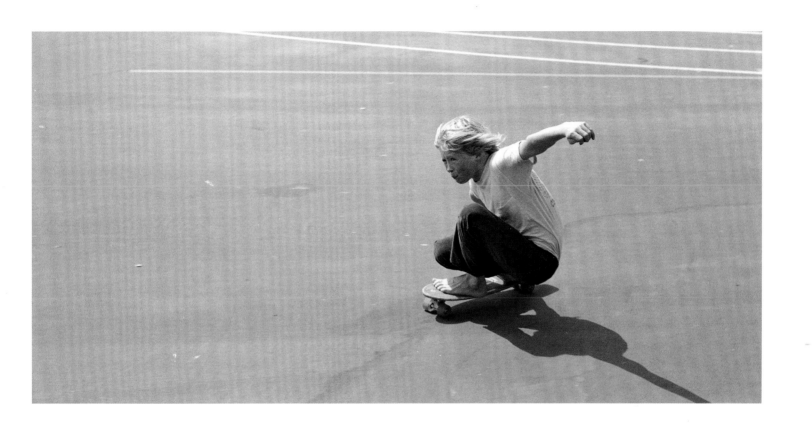

BABY PAUL CULLEN

I was younger than Alva, B Paul was younger than me. Tony used to beat me up so I used to beat up Paul. Just fun kid stuff. B Paul sure had the surf style barefoot at Kenter. That looks like Chris Pasques in the background. He was Kent's good friend who used to go down to Mexico on our surf trips. Kent and him split up and Chris and his wife Ethel took over Z-Flex Skateboards up until a few years ago until they sold it to Greg. Z-Flex is the oldest skate company. Period.

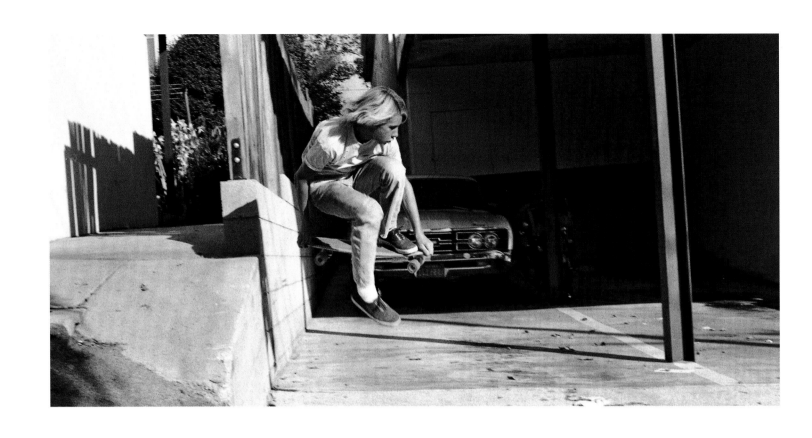

The handstand photo on the right is how skateboarding was. But I
thought you could do it a bit differently. "Gotta try in order to fly."

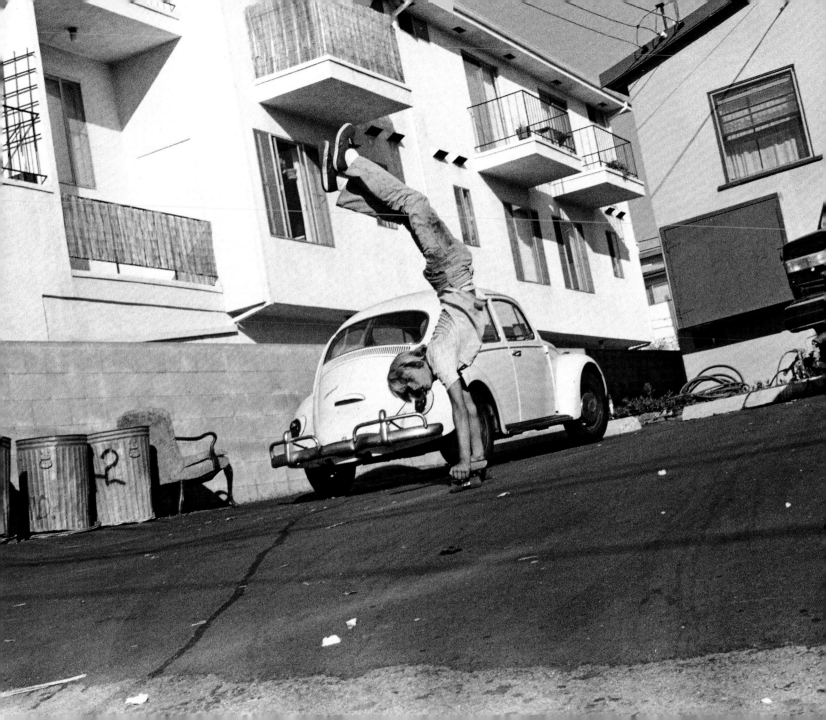

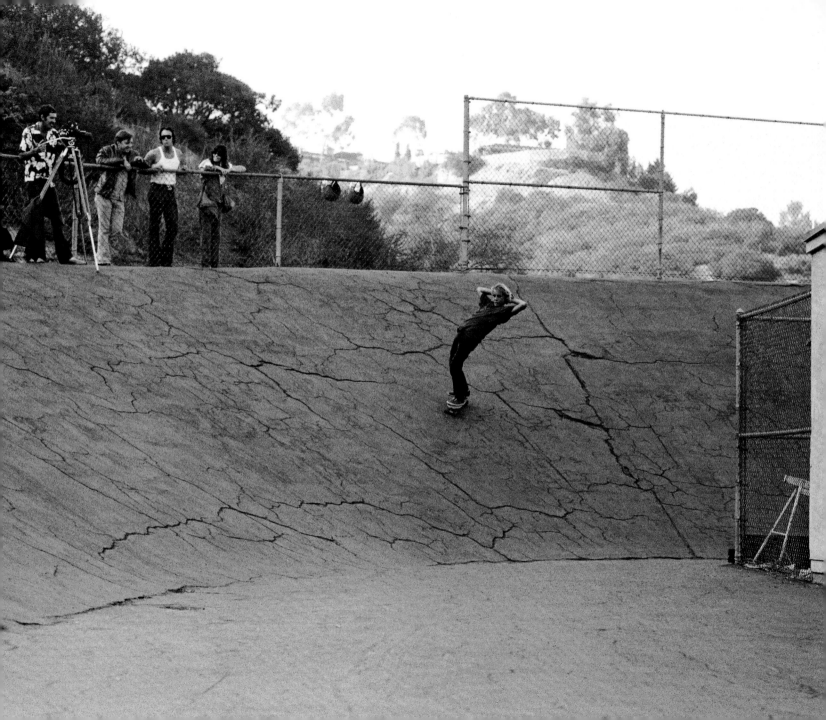

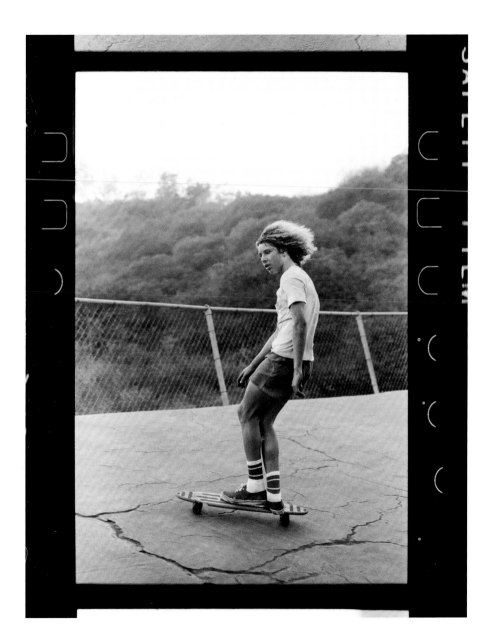

Tony going super fast at Bellagio going up the hill cross stepping with speed. And the other one's me droppin' in while Bunker Spreckels watches on with the camera crew.

This was a day at Bellagio with Tony and Bunker Spreckels was there filming with somebody. Bunker's the guy with the tank top on. He was a super rich surfer guy who loved cruising around the world and partying like a rock star. He took TA under his wing and was the guy in the Dogtown movie that TA hooked up with. He loved fast cars, drugs, chicks with dicks and ended up killing himself with heroin. Live fast die young.

This is another vision I get when I remember being a kid. Kent made me the custom mini longboard at the Dave Sweet surf shop on 11th and Olympic in SM where he worked. I remember the lil cups of foam that they made for the popout surfboards. The foam made a mushroom head outta the top of the cup when it got hard.

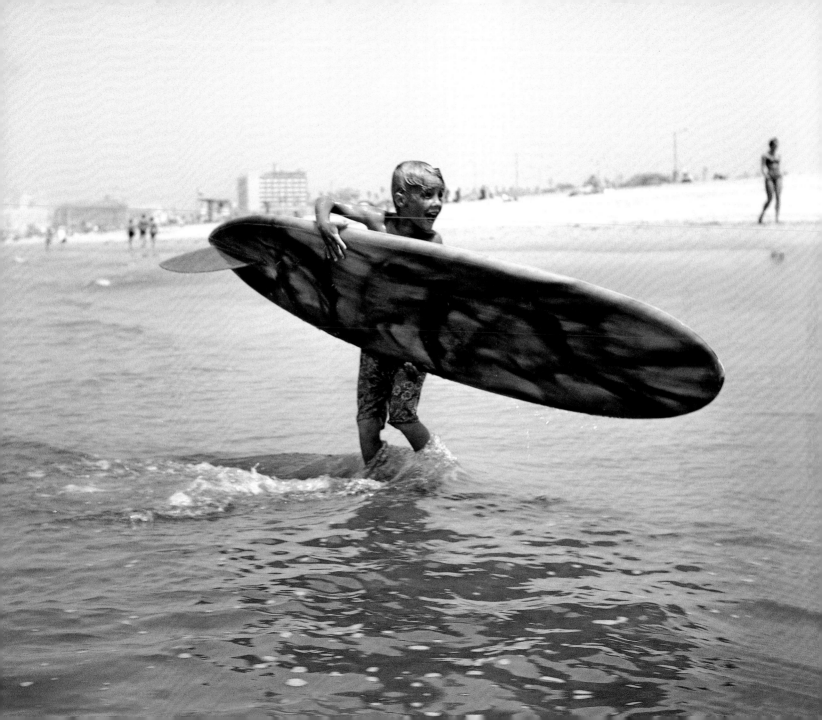

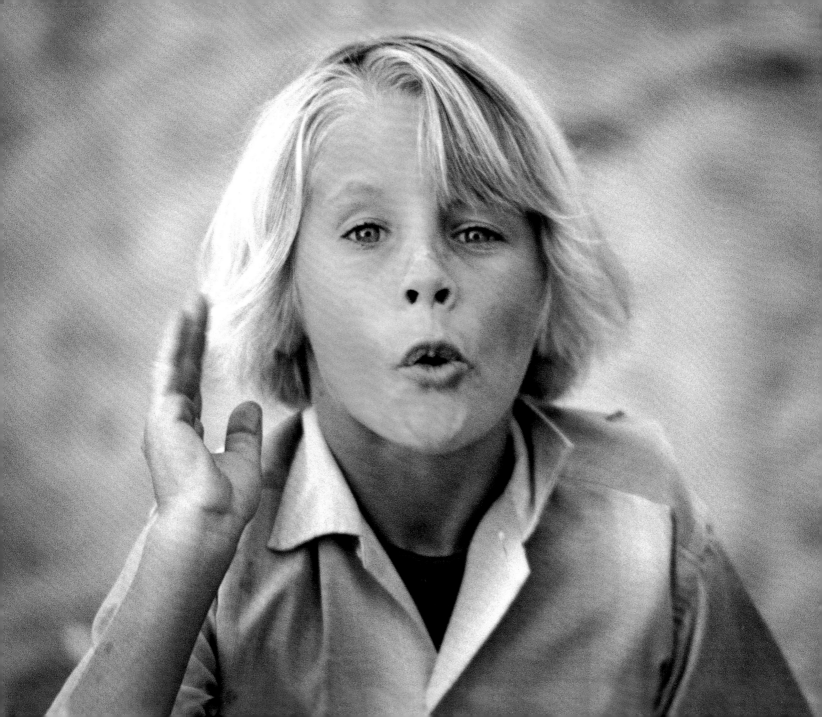

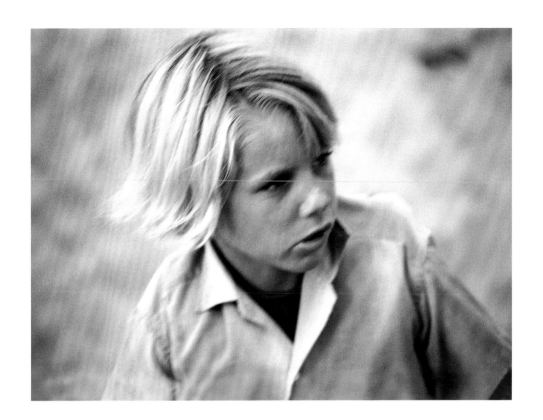

Spitting sunflower seeds in Venice Beach. Look at my nose, my
newborn lil girl Venice has the same one. At least that's what my
wife Alisha told me today during our visit through the glass.
She also told me Venice has my toes. I sure do love this woman.

I dedicate this book to my mom Philaine Romero DogTown Den
Mother when everybody else would run for cover my mom would
take control. One time she had Alva, me, Baby Paul, and Wentzle
all standing with our noses on the wall in the four corners of the
room. I don't think anybody else could have pulled that off.

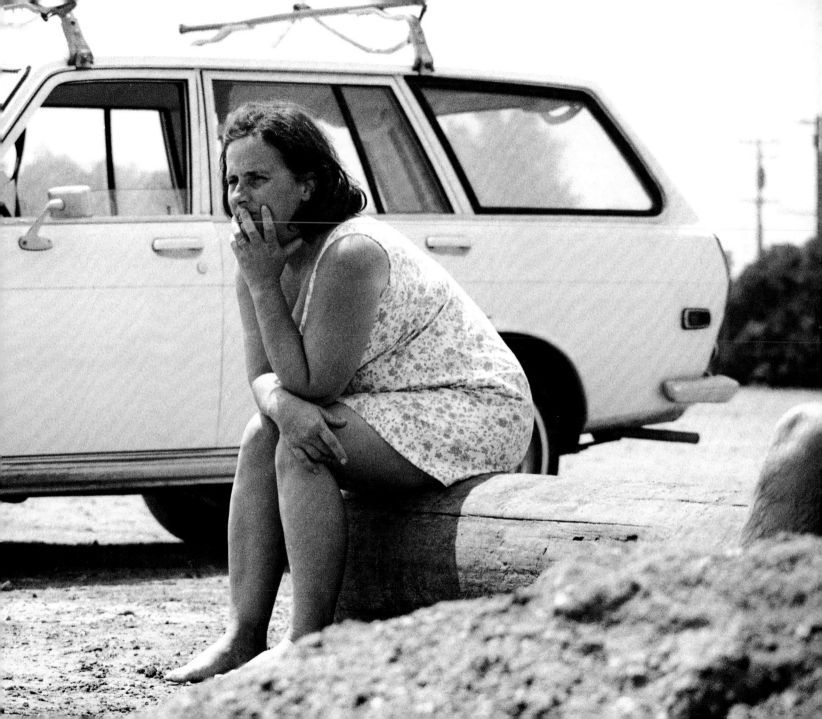

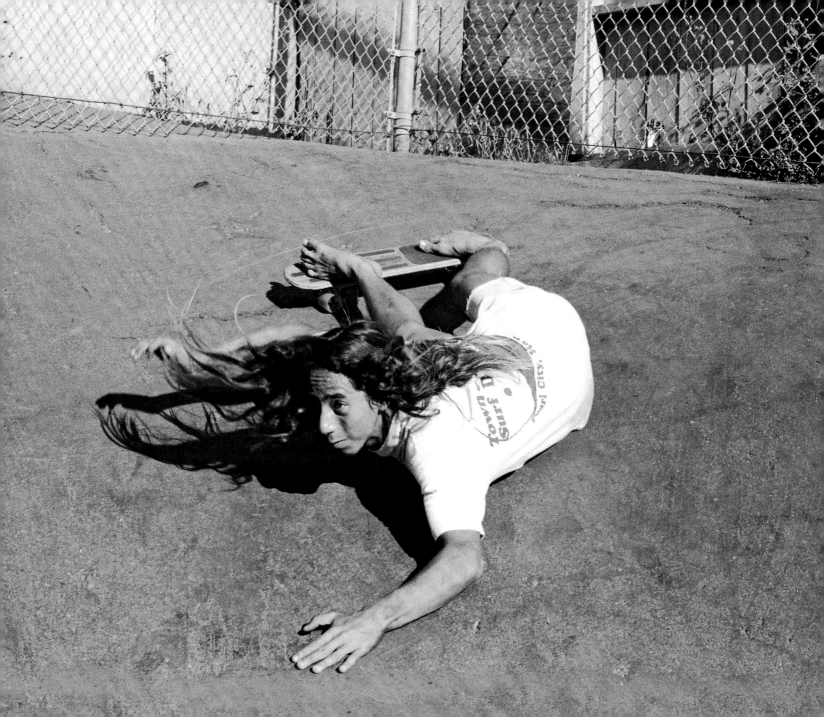

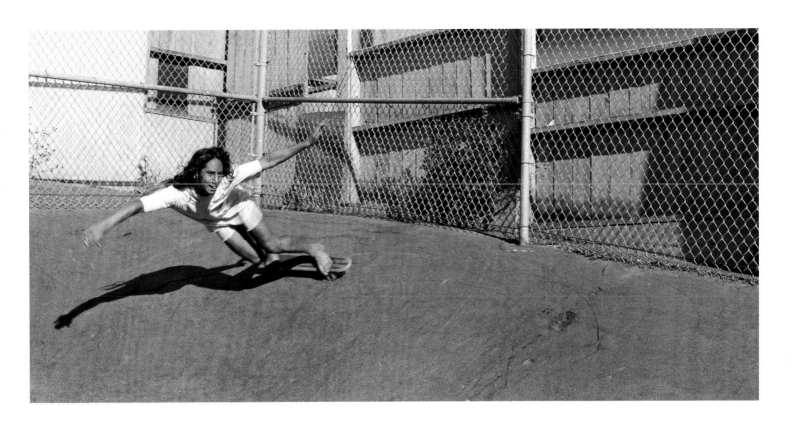

ROY JAMISON
100% Hawaiian barefoot bert in Santa Monica Roy was Hawaii's
best skater at the time. Town & Country was a new surf company
starting out of Pearl City Hawaii. All the Z Boys put their
stickers all over our boards and wore their shirts when we skated.
All the LA surfers wanted to promote anything Hawaiian that
was cool. Plus Larry Bertleman surfed for T&C.

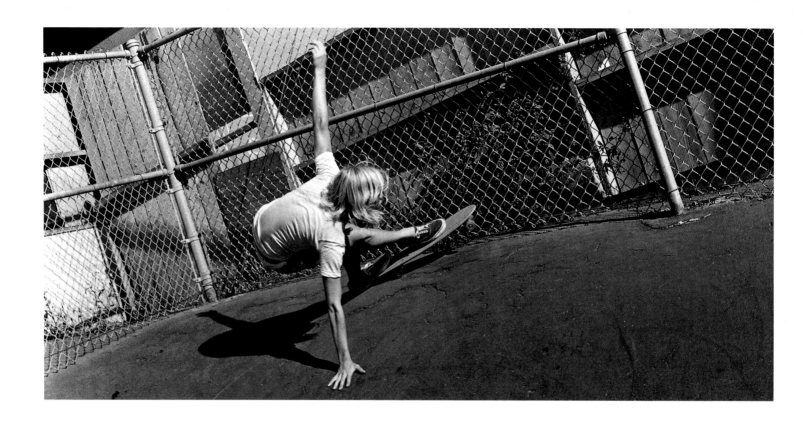

Wentzle Ruml at St Clement's. Wentzle was one of my best friends. He lived right down
the street from me. I'd skate over to his house early every morning before school
and we'd skate down to the beach with our surfboards under our arms. I'm pretty
sure it was him and I who figured out how to count to 10 at the top of 4th and Ocean
Park in order to fly right through the green light at Main St. That's how they opened
up the *Lords of Dogtown* movie, showing Alva eat it at the bottom of the hill.

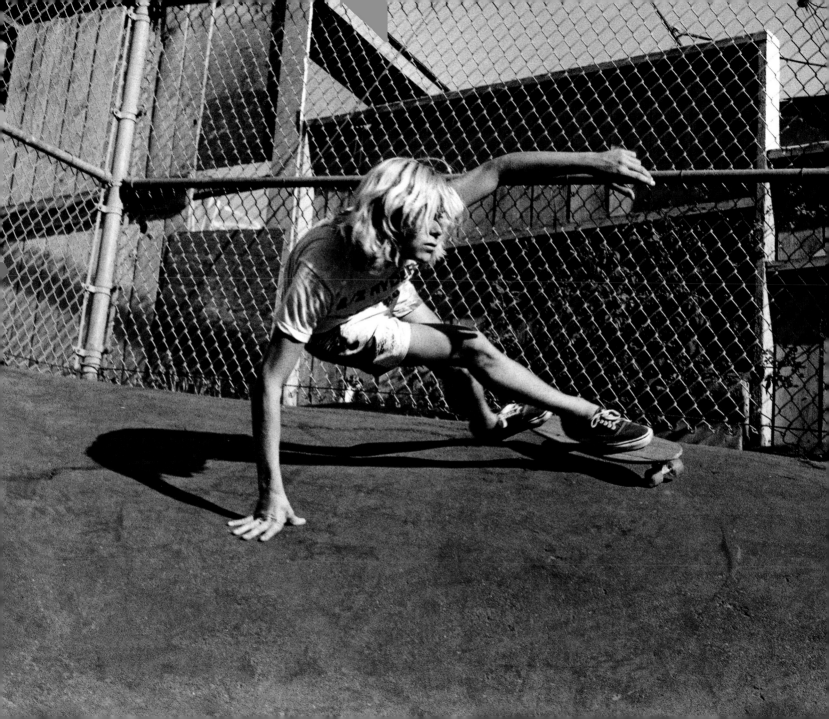

Me paddling out at Pacific Ocean Park Pier. The pier was my playground all summer long. All the guards knew me so they let me in for free. The pier started where the rocks are and went even farther than you can see in the picture. It also went back a couple hundred yards deep. It was dark in there, we used to get flashlights and explore the whole place, we'd bomb the wino farts who used to bug us. Every day was an adventure. But the best part of the whole amusement park was the waves that broke in front of the pilings. Lefts in the summer then rights in the winter. I grew up surfing that pier. Starting out at Tower 22 getting good enough to surf the Ts then going on to earn my spot as a young kid at the Cove.

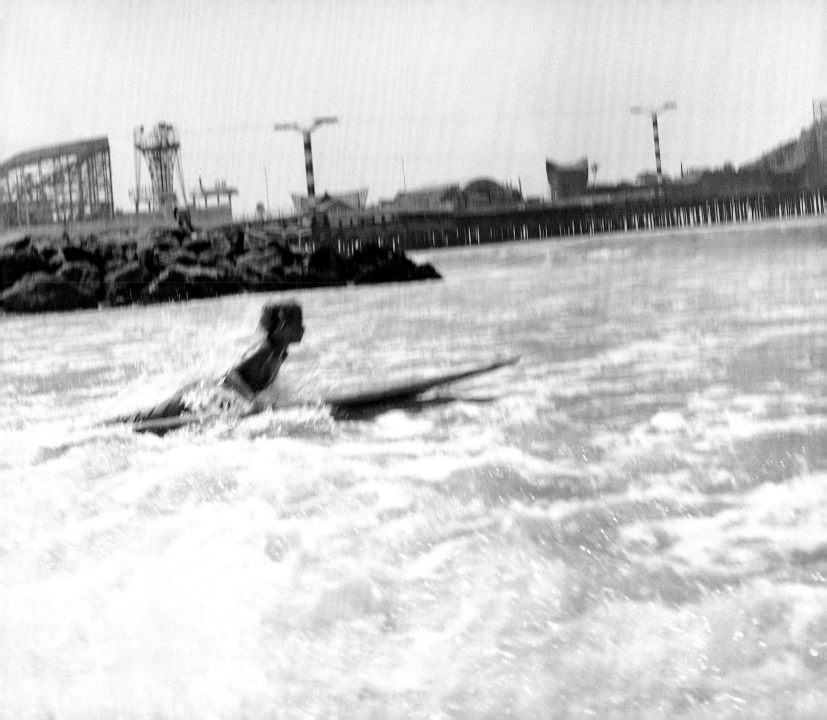

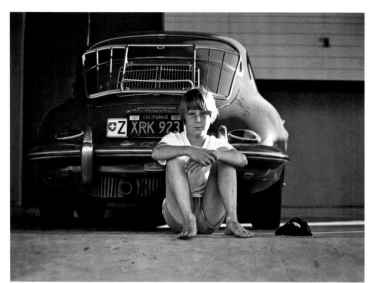

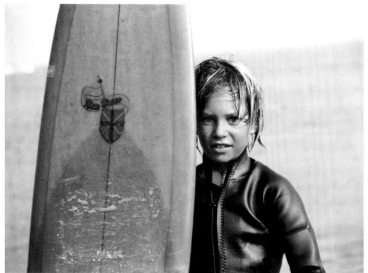

Kid who lived next door? Matt Warshaw

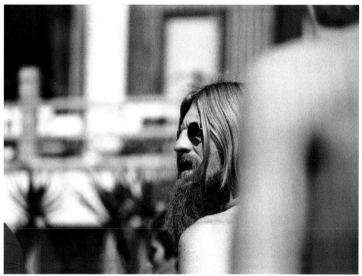

Kent always had an eye for the pretty girls. My mom never seemed to mind, not in front of me anyway. Don't know who she is.

Who's that? The Zig Zag Man cool shot. Maybe it's Cheech looking for Chong?

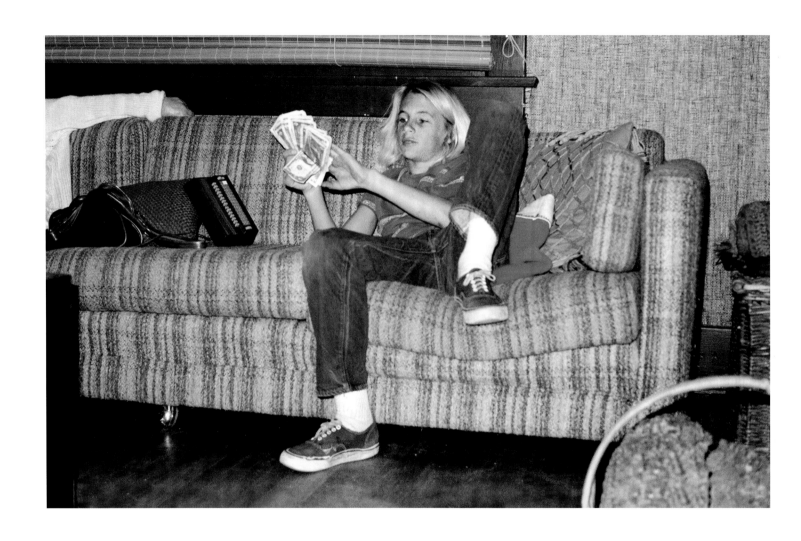

It was either Christmas or my birthday and I got fifty 1 dollar
bills. At the time it was a lot cause you could catch a bus for 25 cents.
5 bucks would get you to Oxnard and back.

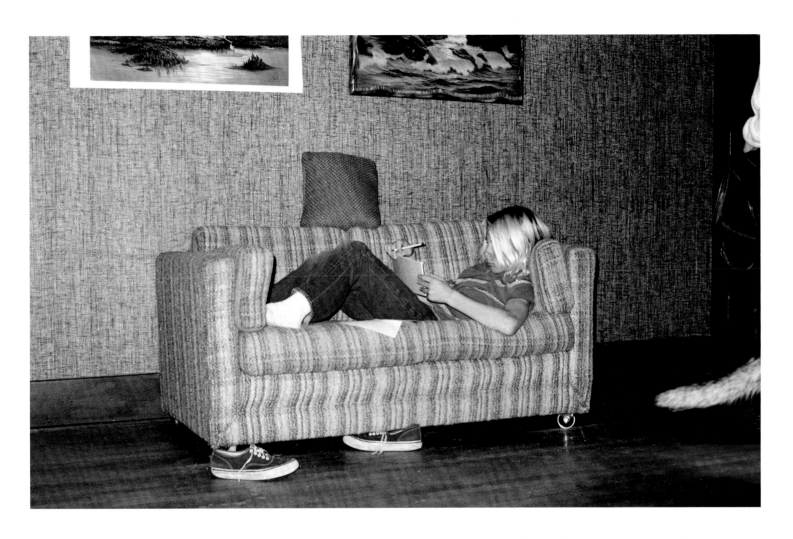

The big couch was my mom's. Kent had the lazy boy chair. And this one was all mine. I know that's not homework I'm doing there 'cause I really didn't do much schoolwork at school much less homework at home. Oh yeah, those aren't Vans either. Vans came later. Those are deck shoes that we bought at Kenny's shoes.

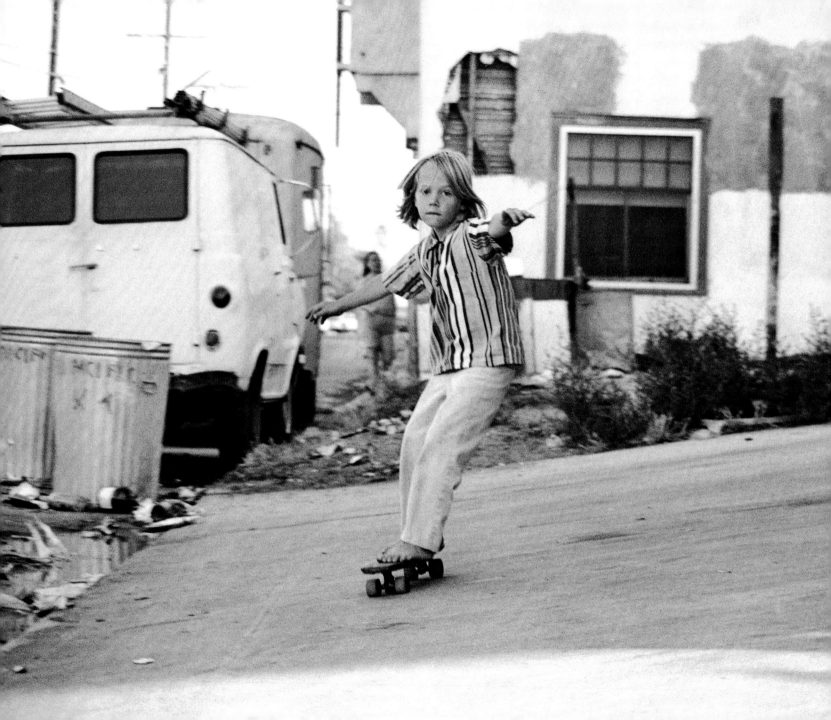

Can't remember his name but he lived next door to me. This is the driveway next door to my house we called "the shack." The Shack was the old Velzey surf shop on Pacific Ave in Venice. It was a lil one room place with a metal roof so when it rained it was super loud. It later became the Z-flex shop.

It seems like every best friend I ever had ended up surfing or skating sooner or later. I think this kid and his brother moved outta California after people started talking about California falling into the ocean.

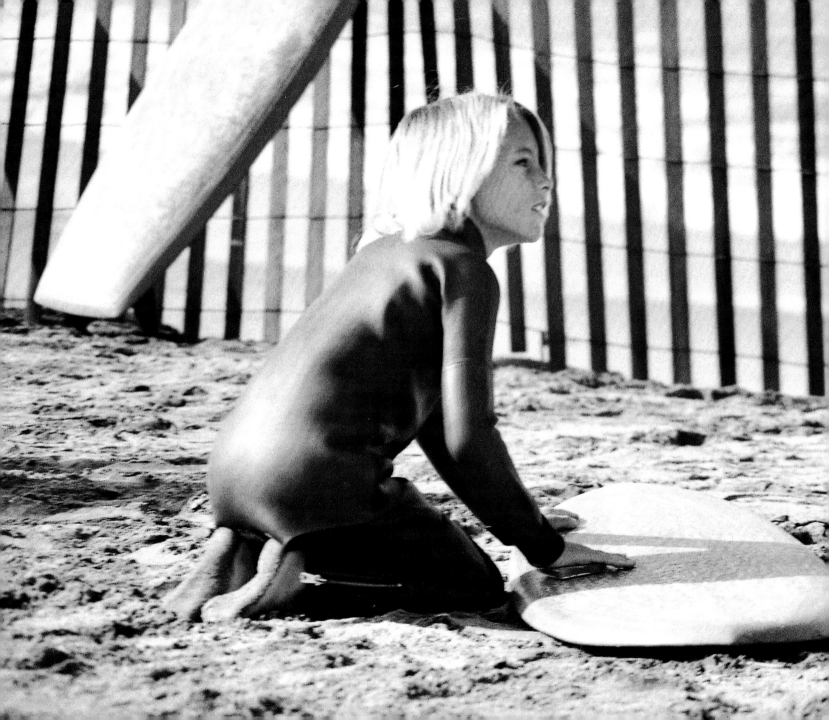

This one is me waxing my board before a heat at D&W. I paddled out and the waves were bigger than they looked. I have another picture of me going over a big wave for me at the time it was or must have almost been a real 5 footer. But at the time it looked 20 ft. to me.

For sure one of my first pool photos ever taken. This was before
Friedman or Stecyk started taking photos of all of us in pools.
Tony reminds me he had to talk me into liking pools at first but
I really can't remember those days.

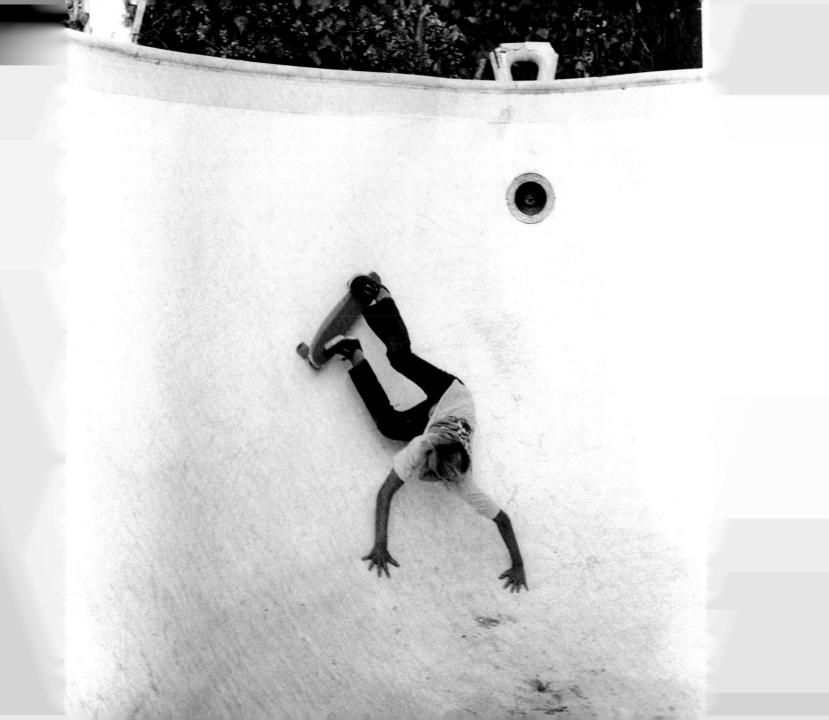

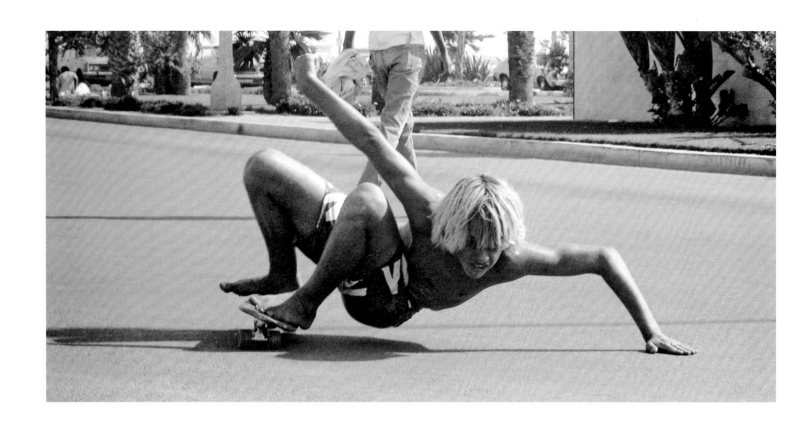

I remember Ty Page said in an interview in Skateboarder Magazine that all the DogTown Boys had a monkey style except me. But I think I look like a lil monkey in this photo. TA and Ty Page were about as opposite as Malibu and Pipeline. Both were good skaters but I think TA took it to the next level after Ty stepped down.

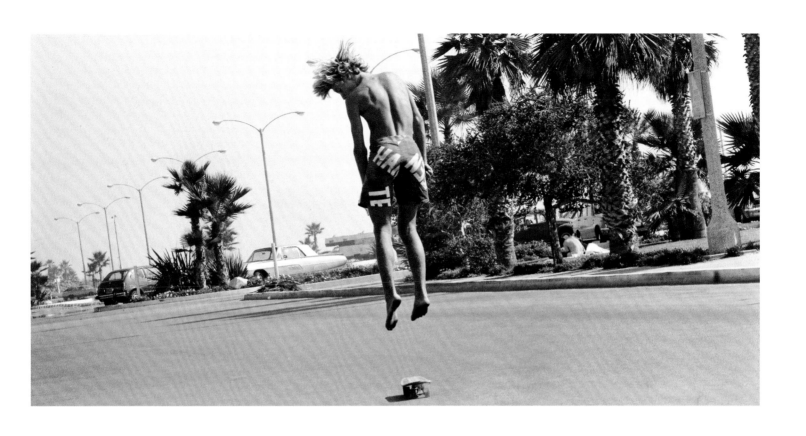

This is the parking lot at the beach at Ocean Park. I just like the Hang Ten shorts.
I don't know about the lil pirouette thing. Hey maybe this is really a picture of Peralta.

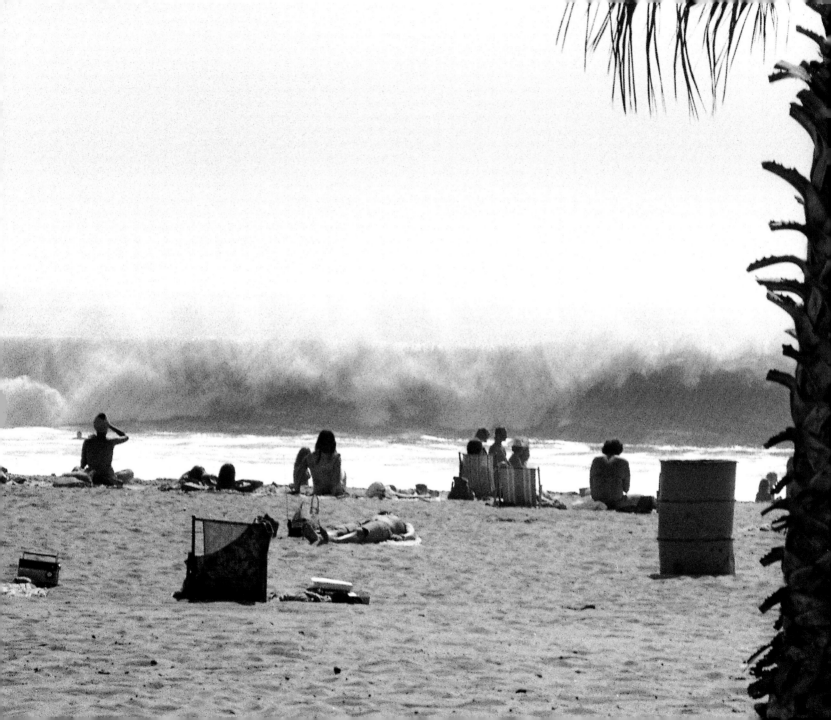

Waves like this at Ocean Park only meant one thing, get to Malibu quick.

Kent got me the shorts made custom at the store in Haleiwa Hawaii.
I live in Hawaii and still can't remember the name of the store.
It's right next to Mutsumoto's shave ice or whatever it's called.
How's that only me and the invisible man surfing at the Bu.

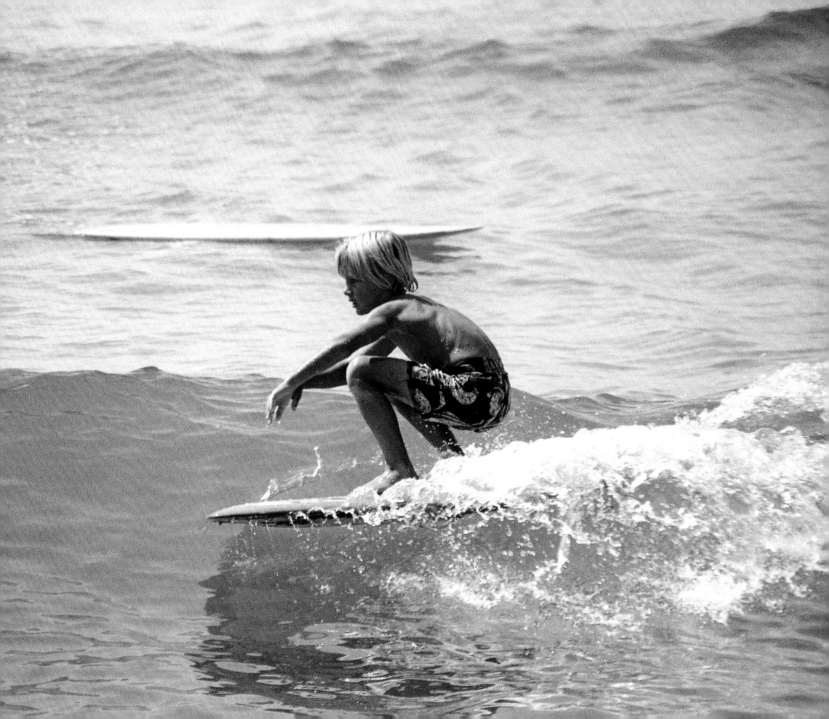

I remember skating the bank out front on Marine St with Torger Johnson to me that was like surfing with Jerry Lopez. I bet Wentzle was there also.

Wentzle flying in his EZ-Ryder shirt. Me and Wentzle used to ride our skateboards everywhere. Who needs a bike when you can surf down the street.

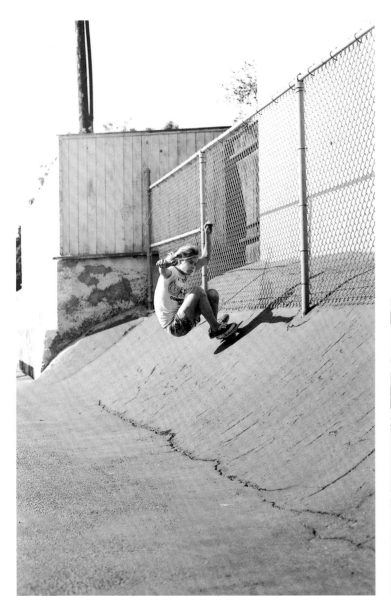

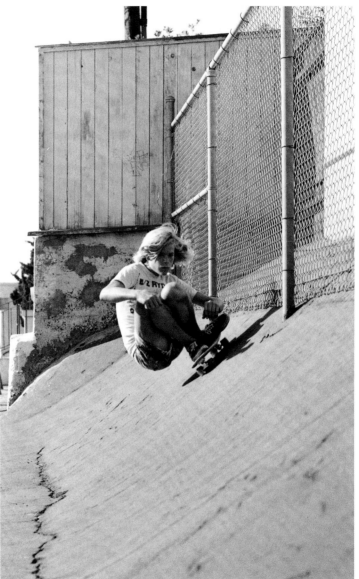

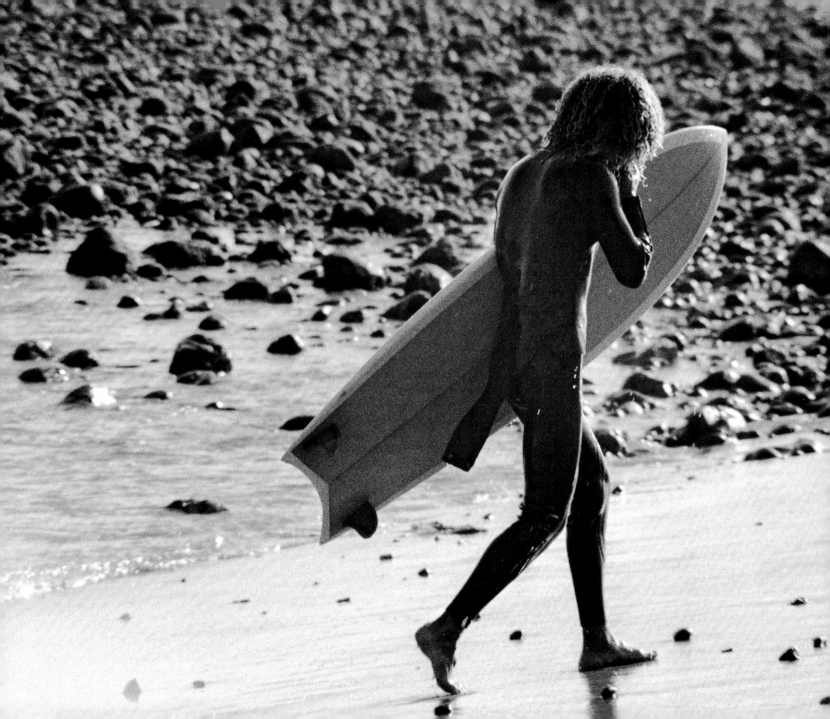

Not quite sure who this is, could be Alva huh? Look at that hair. I like the twin fin but the beaver tail really rules. I met Tony Alva when he was hitchhiking on the side of the PCH on the way to Malibu. He was a kneeboarder at first but I bet he don't remember that part.

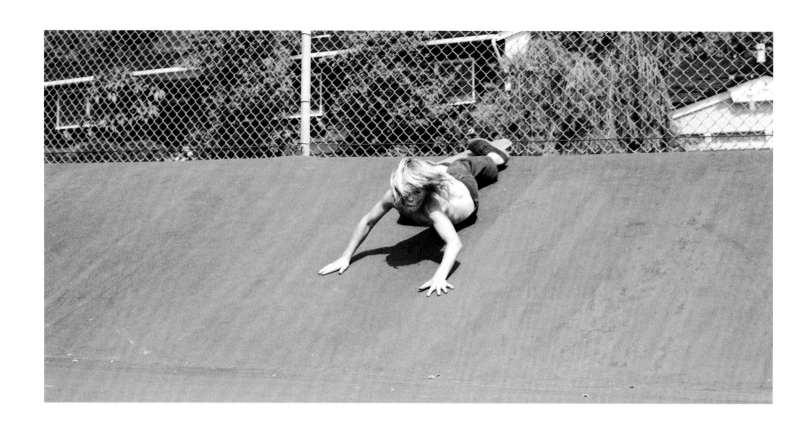

Baby Paul Cullen & Tony Alva. Alva was the king of skateboarding
at least in our world. Later on when we'd go to a pool or skate park
99% of the kids would stop skating and watch. B Paul must have
been the happiest kid in the world 'cause Alva was his teacher.

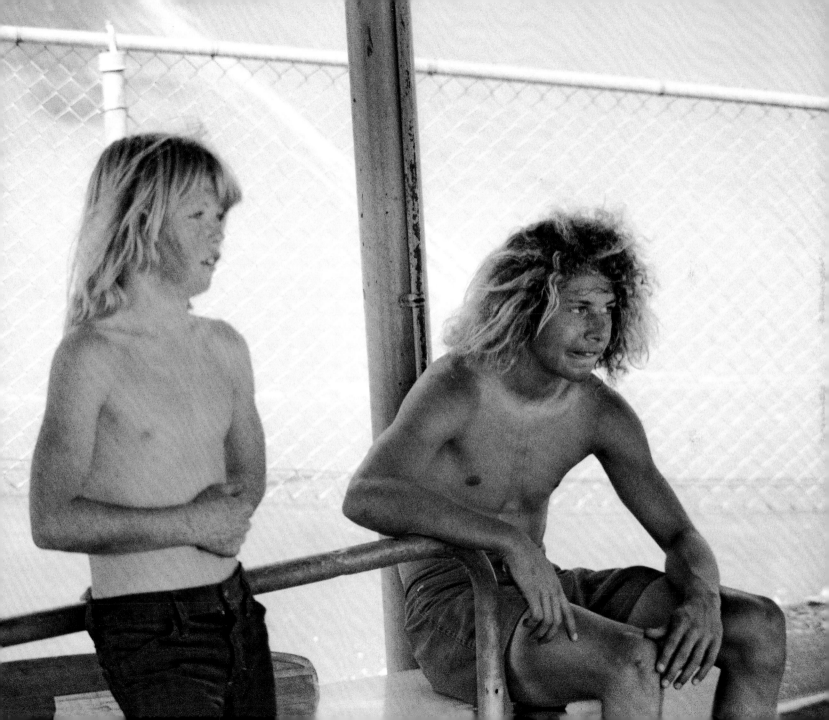

Shogo at St. Clement's school. Some days we'd have 10 or 20 kids ripping around this little bowl.

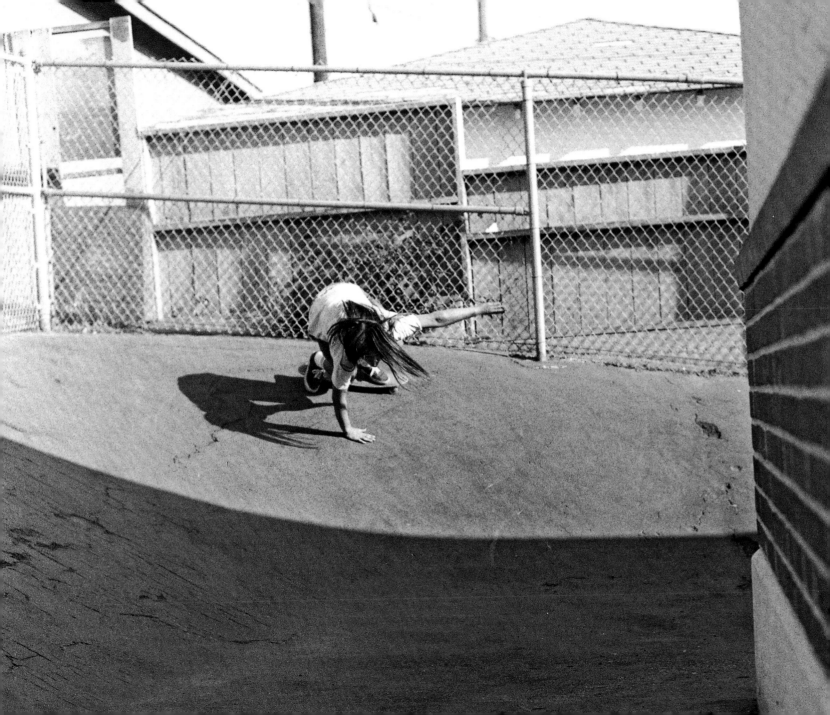

Paul Revere Junior High School

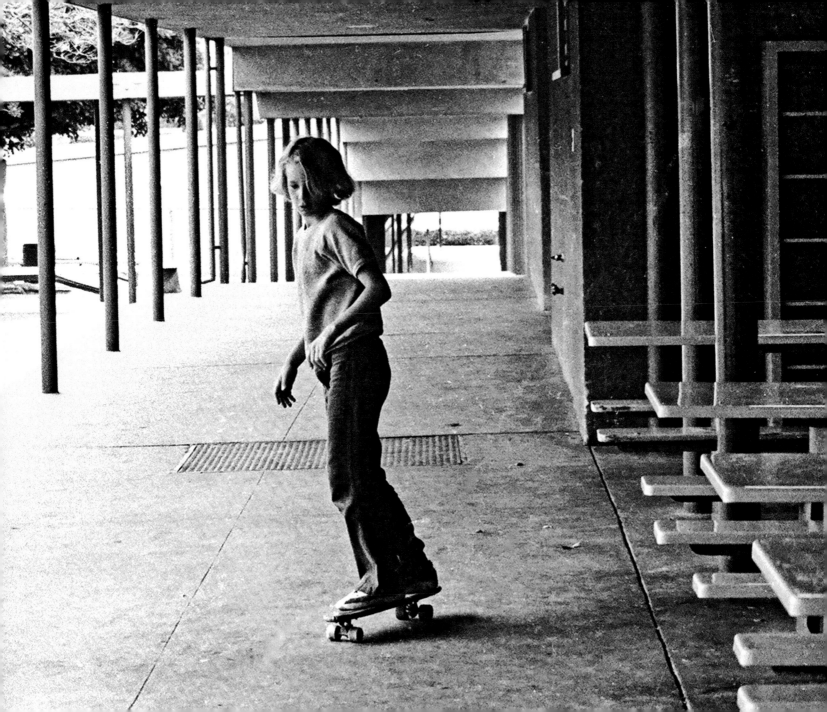

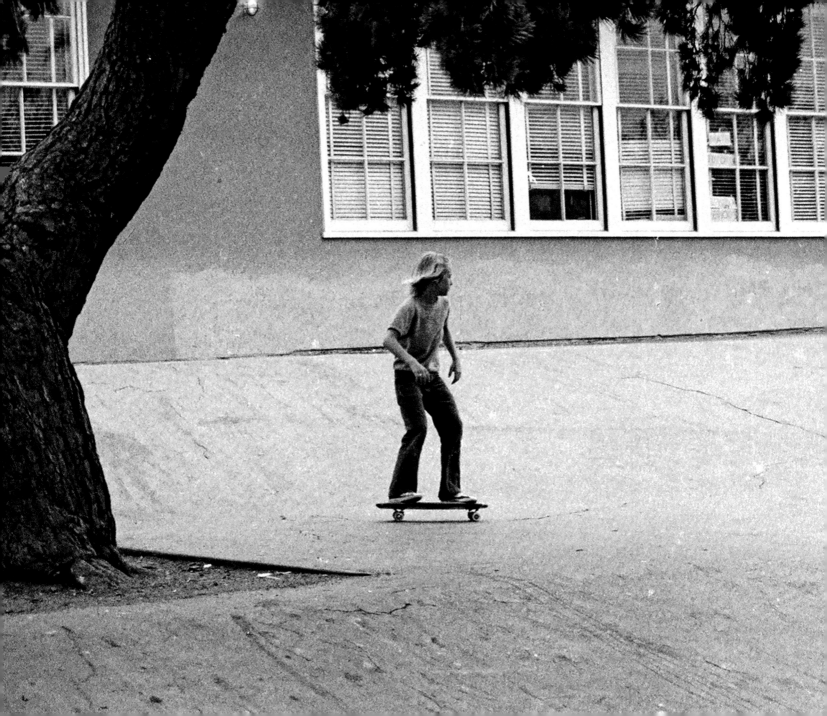

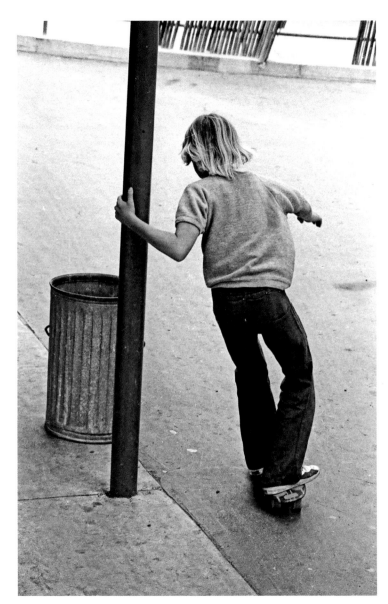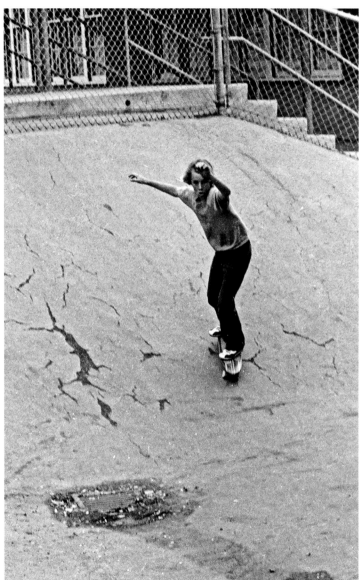

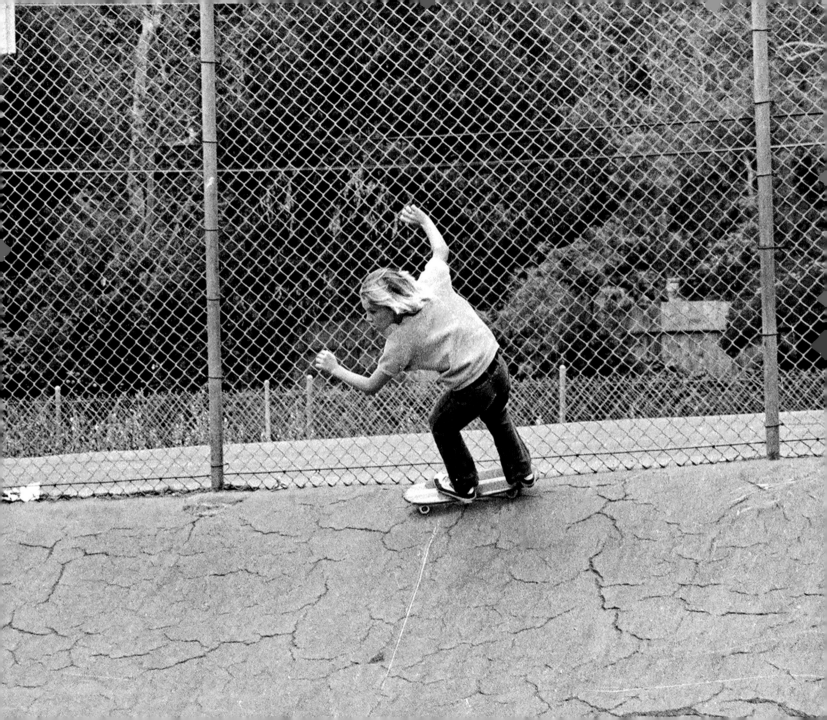

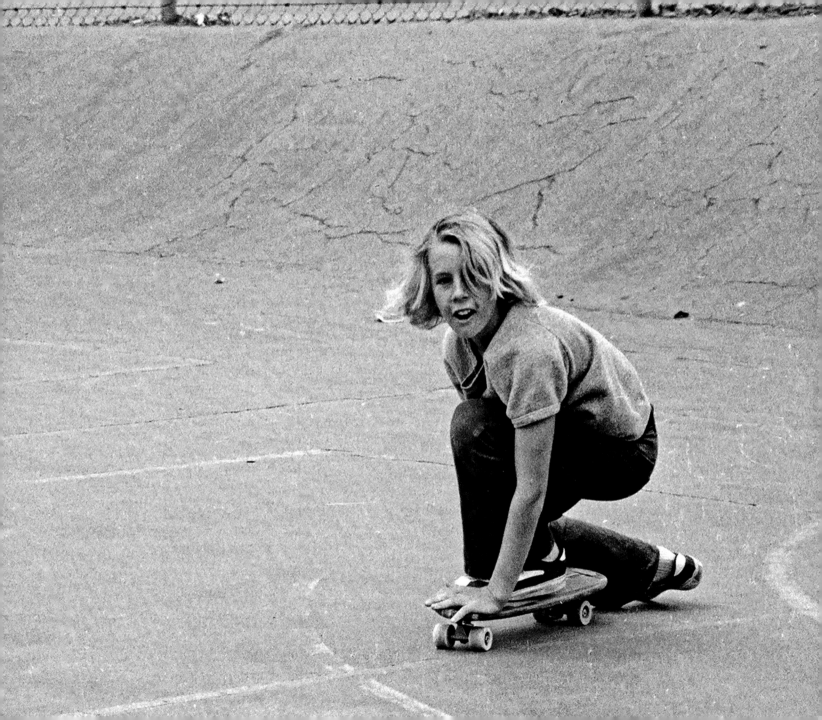

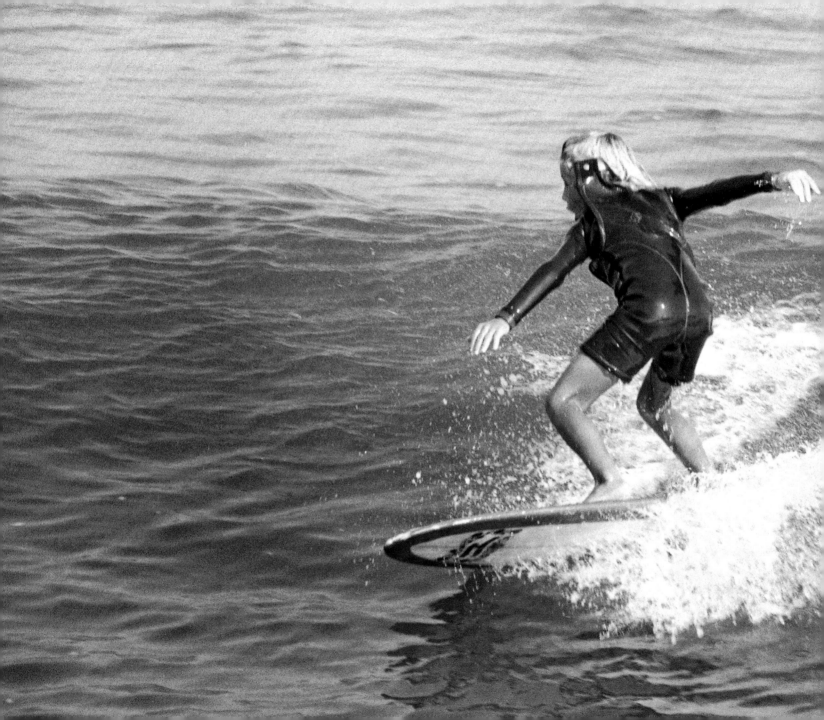

Me at Malibu about 9 yrs old. The surfboard is a Donald Takayama reverse teardrop board made custom for me. I also used to have to go down to Redondo Beach to order custom wetsuits from Body Glove 'cause nobody sold small suits back then.

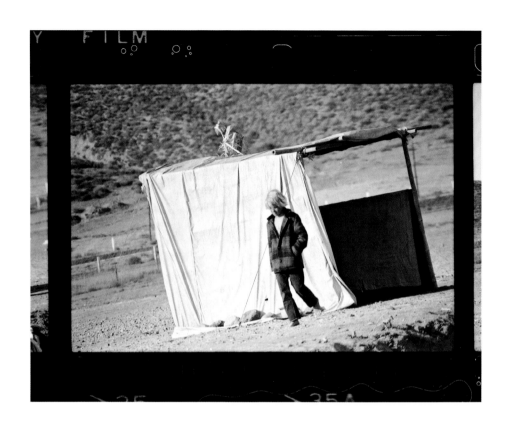

Me and Moms at K 38 in Mexico checkin' out the surf. I just found out
Moms hated Mexico 'just a big ol' dry desert all hot and dusty. Moms
should have surfed 'cause she wouldn't have thought that way if she did.

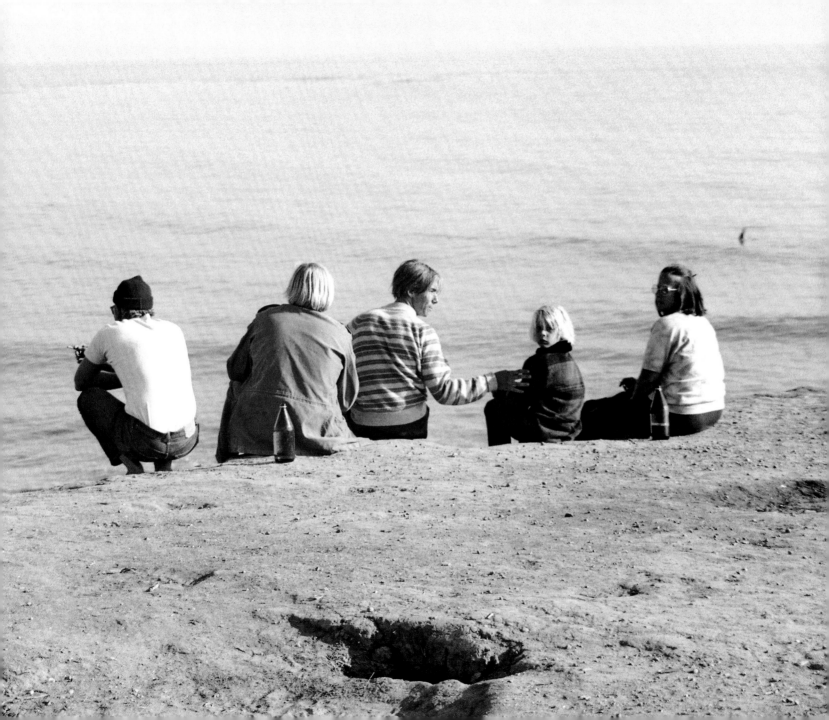

Auntie Sandy. She's the one without the glasses. She's the first
woman to ever get me excited. I think I told her to show me hers
cause she was seeing mine while I was in the bathtub. Man, her and
my mom must have been mankillers in their day. Sandy died of a
heart attack in her late 20s. I really love this picture 'cause it
shows two hot sixties chicks at the beach at POP Pier. I bet the
boys at the pier were happy when Kent brought his chick's hot sister
down there. Not sure who the other lady is.

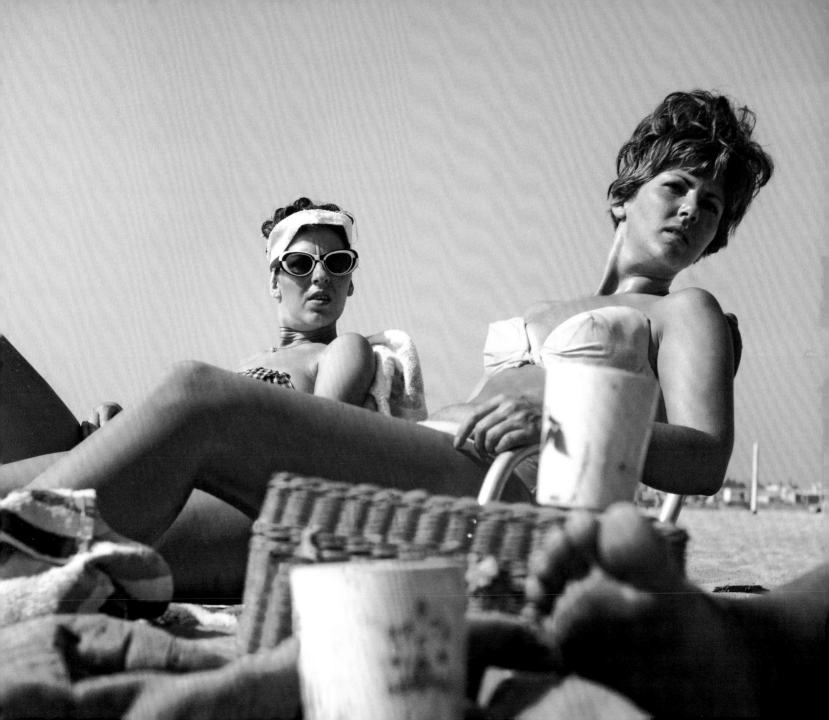

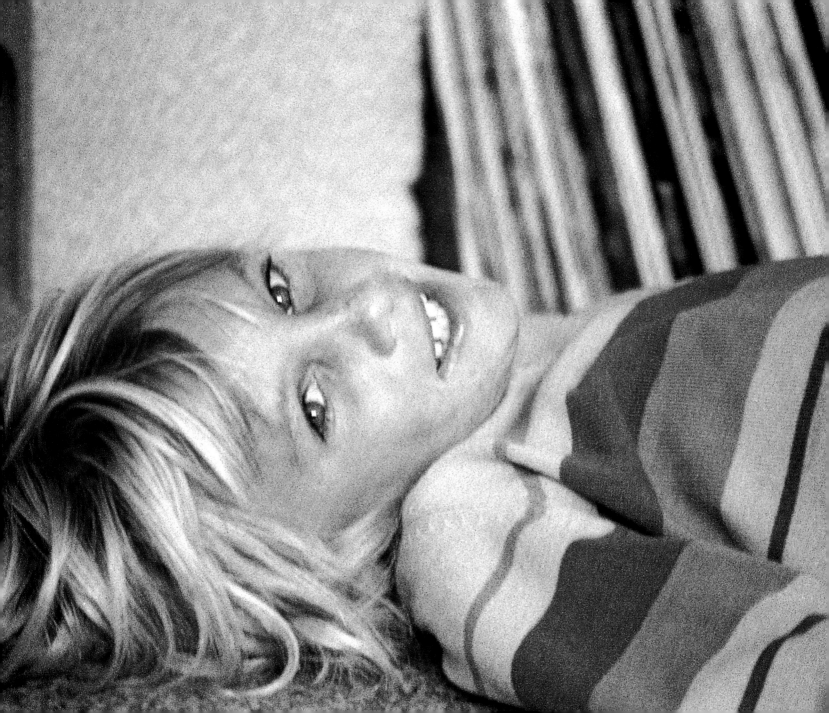

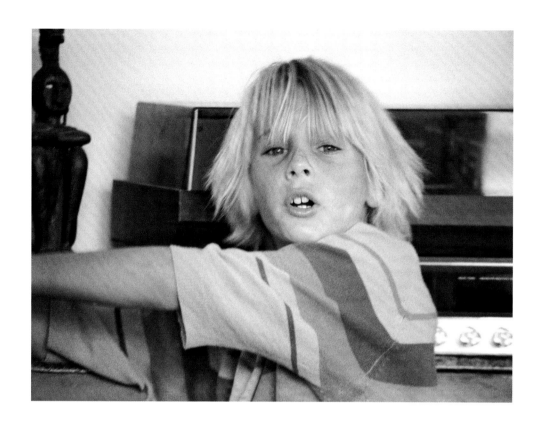

This is at our house on North Venice blvd. I used to listen to The Beatles White Album and the song "Number Nine" used to scare the heck outta me. And the part in the song Strawberry Fields at the end when it says "I buried Paul."

Halloween day in front of my house on Linnie Canal. I loved growing up in Venice. My next door neighbors were a biker gang called Satan's Slaves. They used to babysit me and cruise me around on their bikes. I remember the biggest problem in life was 2 try to be the first guy who picked Gilligan as who I was gonna be when we watched the show. I had a huge tree house and about 10 different fruit trees in my yard that looked like a jungle.

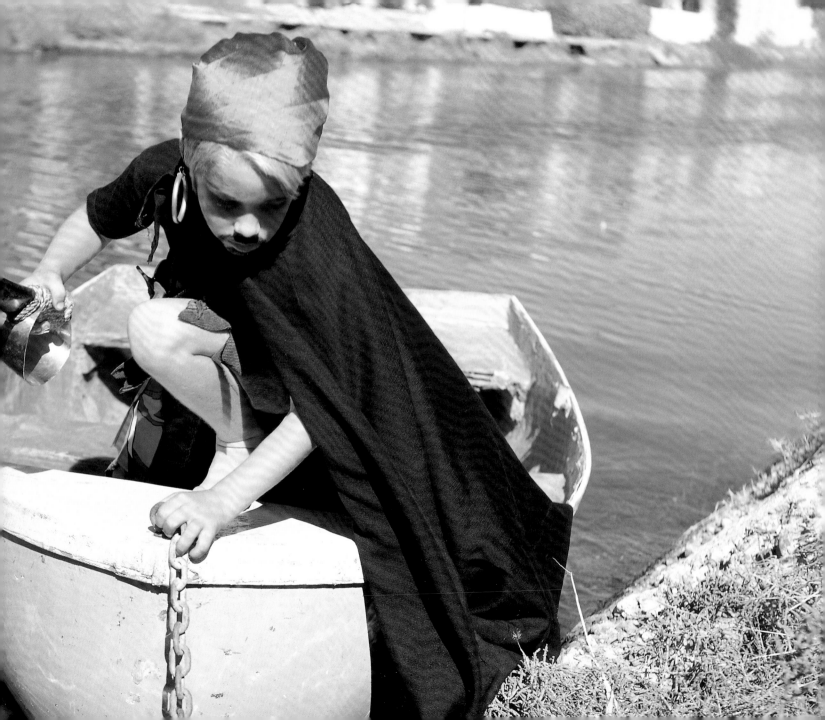

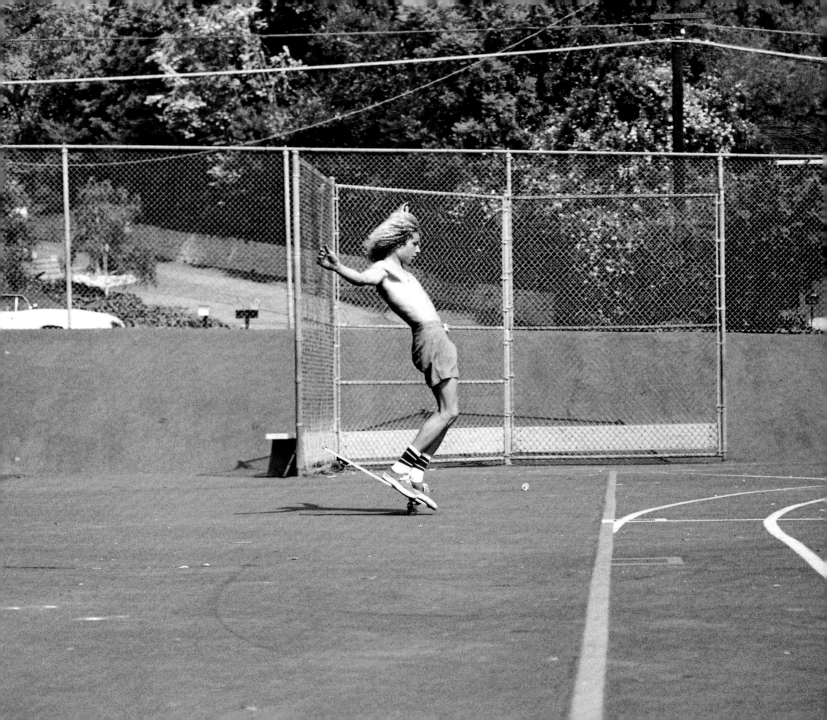

TA at Kenter trying to learn a nose wheelie, probably so he could get his picture in the Magazine or win a trophy or something.

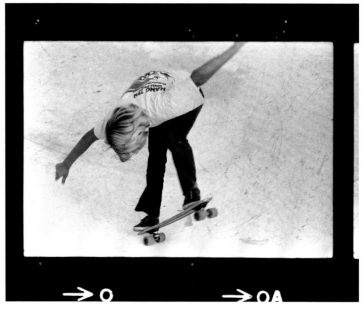

OG Dogtown Skate. Looks like a pool session might go down somewhere. That's how we used to do it. Cruise down the alley on top of the car looking over every fence for the one pool that looked good and hopefully nobody lived there. Or they had to go to work everyday.

I'm not sure but this might be at the Rabbit Hole pool in SM. It's the first pool I ever skated. The shirt I have on is from the Hang Ten world contest. I remember that because I got first in freestyle and first in cross country beating Ray Jamison in both. He was bummed but got me back at the next contest in San Diego by getting first to my 2nd. Or maybe San Diego contest was first. Oh well who cares, right?

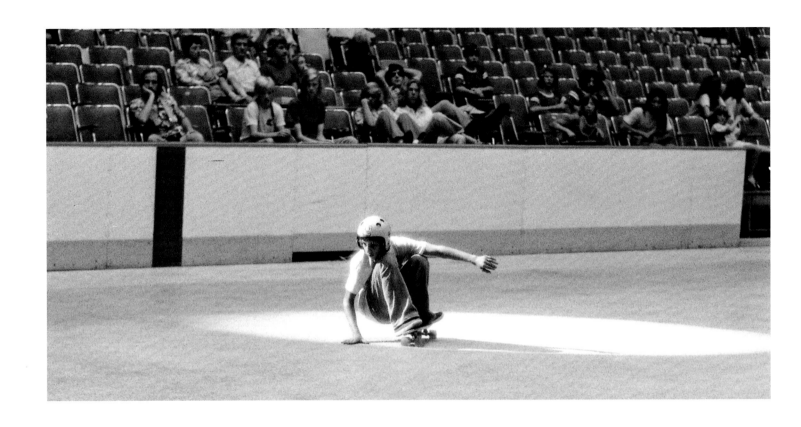

This is the '75 Hang Ten world contest at the LA Coliseum. They had the finals at about 11 or 12 at night. I remember this contest because I got 2 first places. I got first in the cross country event. I remember my time was 1/10 of a second slower than TA's and he won the men's. I made a 180 off the jump ramp and that's about the only contest results I can remember. (I can't remember doing switch Berts. Maybe the photo's reversed or maybe I just ended up going backwards after landing the 180 off the ramp.)

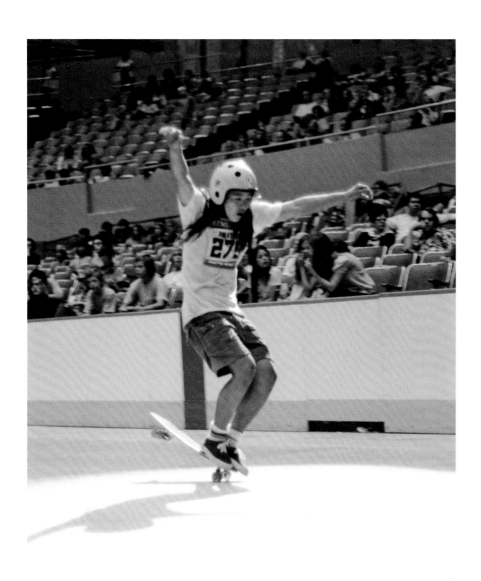

Shogo at the Hang Ten Pro-Am world contest,
nose wheelie.

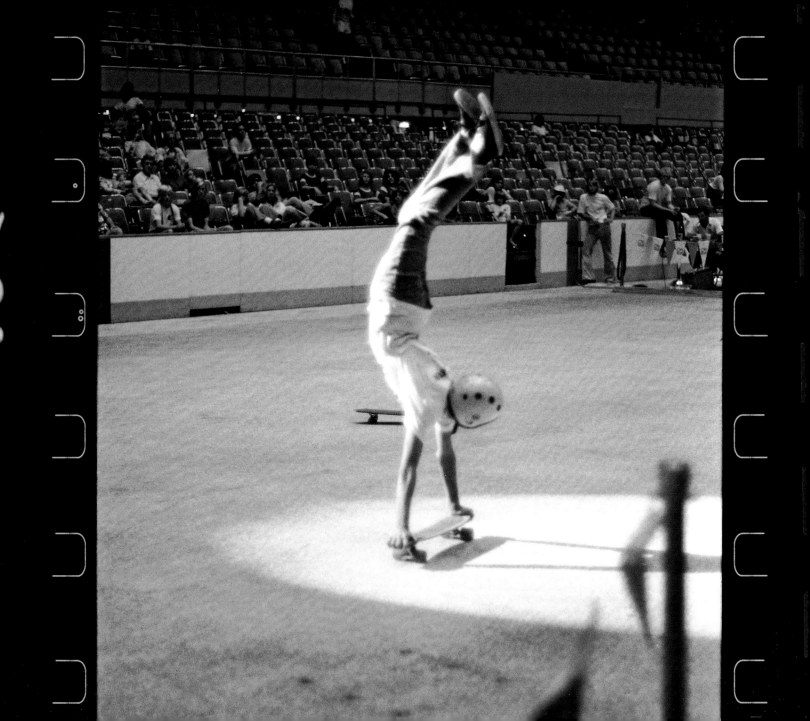

This is my Ty Page imitation.
At the time hand stands helped you win contests. There weren't any
ramps to grind on. But this one was the first contest I remember
having the jump ramp. Check out the spotlight. Contests were
still pretty fun at the time cuz nobody was making money yet.

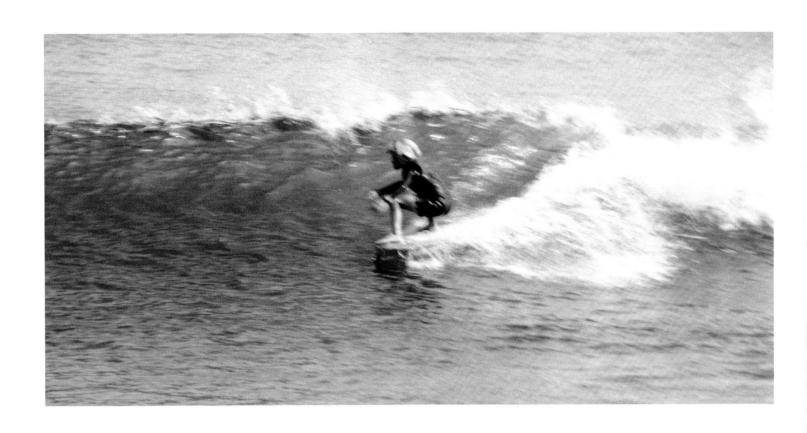

Hanging five or cheater five. Whatever you want to call it, I kinda like the guy in the background. Malibu was a great place to actually take surfing up a step or two. There's always been really good surfers out there since the beginning.

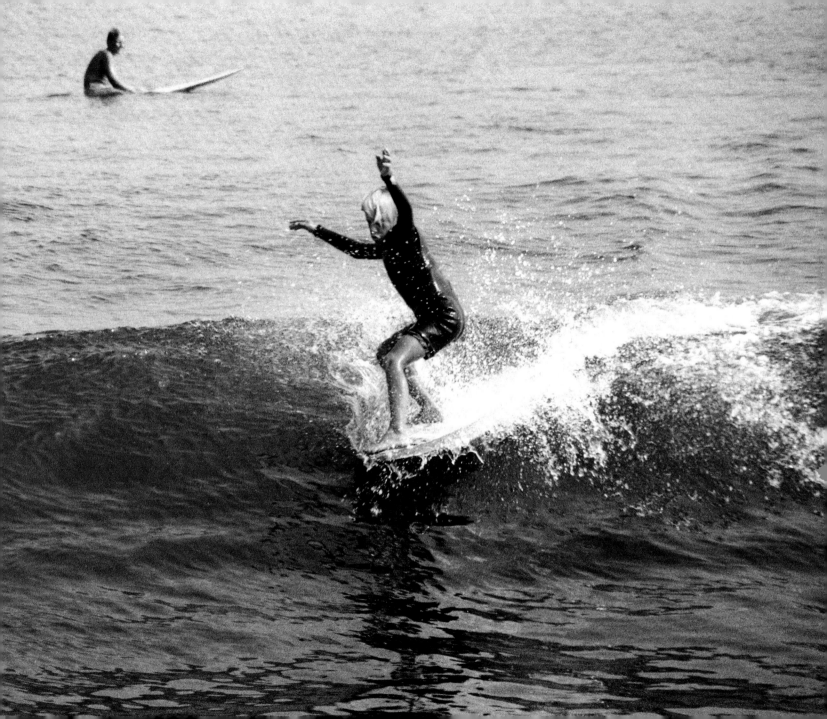

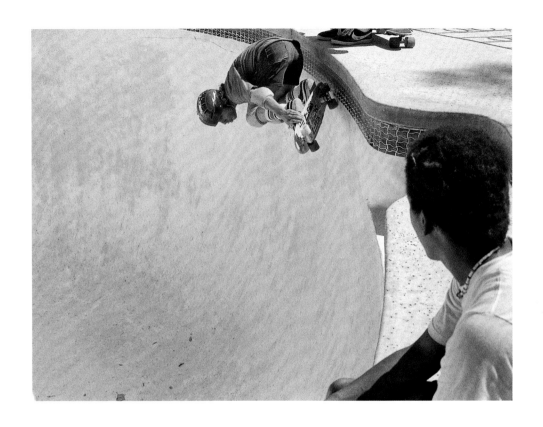

Marty Grimes watching me skate a pool in San Diego. Marty was one of the raddest skaters ever. I met Marty at the Santa Monica Civic Auditorium at a surf movie. We all used to skate in front of the Civic before and after the movie. Marty showed up with 5 of his friends. All black kids from South Central. We ended up becoming really good friends that night after I saw how good him and all of his friends could skate. He got on our team Z-Flex and became one of the top pool riders.

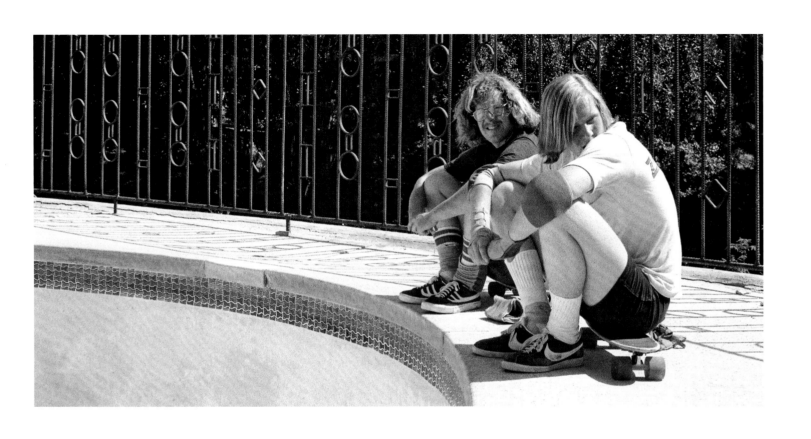

WES HUMPSTON and JIM MUIR
Wes drew the first skateboard graphics which later with the help of Muir
became DogTown Skates. Look at Muir's board it's a hand-shaped original.

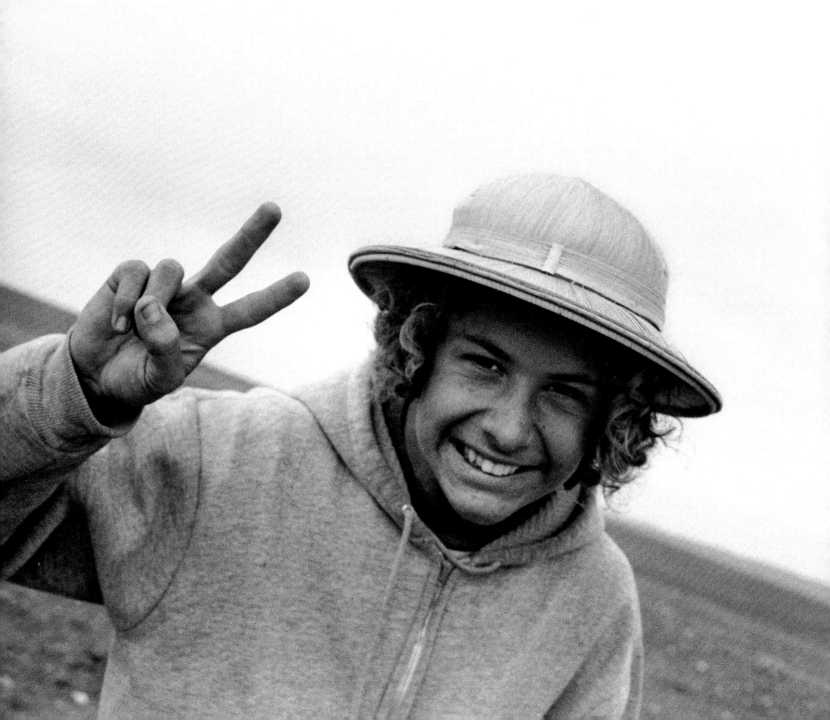

TA in Mexico

Look at that barren dusty desert in the background.
Now I know how my mom was thinking.

I remember on this trip we were throwing rocks at the
seagulls and Tony hit one and knocked it down to the ground.
We thought it was dead but it woke up and flew away.

Home sweet home at the shack in Venice.
My mom and Kent were hippies, we lived on
the Venice canals. That was hippy heaven.
They used to have the biggest festivals in
the canals. Bands playing for 3 days straight.
It was like a mini Woodstock.

Although I never new my father, Kent
was my dad. He never beat me or my mom
and I never saw him do any drugs. He's
the reason that my life has revolved around
surfing and skateboarding. Definitely the
best dad any kid could have.

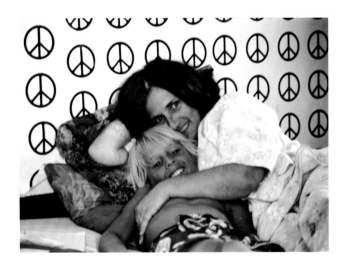

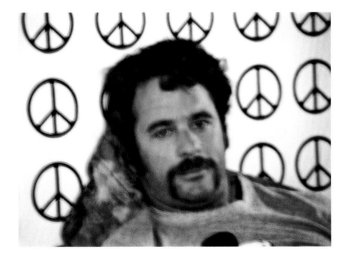

First of all I want to thank our Lord and savior Jesus Christ. Through him all things are possible.

This whole book got started after I married my beautiful wife Alisha and Kent gave me a notebook filled with old photos he'd taken over 30 years ago. I showed the photos to some of my friends who agreed that other people might enjoy to see them also.

So I got in touch with Glen Friedman, who I've known since we were both young teenagers back in the day. Glen and I got our first photo in a magazine together. Me skating and him behind the lens. He thought it was a good idea also, and actually put this whole thing together.

I decided to write out the captions for the photos, putting down the first things that came into my head. I could have used a dictionary or taken extra time to make my writing really neat but I thought I'd just keep it real and not get stuck thinking too hard about my captions.

I think me and my friends were lucky to have been a part of this era because skateboarding and surfing were both evolving from how they used to be to what they are today. Some people tell me how much better it was in the good ol' days and I them 'em "you're living the good ol' days right now, it's just gonna take 20 years to figure that out."

Things have changed quite a lot since Friedman and Stecyk were taking photos of all the DogTown boys. We were all lucky that Craig painted such a pretty picture of our whole scene. These photos that Kent took were actually a few years before our whole group of guys started getting our pictures in the skateboard magazines.

Everybody has cool memories of their childhood days. I'm just glad that I got lucky enough to have a dad like Kent that decided to take some pictures of 'em so I could share them with you.

Thanks for everything

Jay Adams
2006

Just a lil bit of punk rock attitude before all the hair got shaved off. FU if you don't like it. That was my attitude at the time.

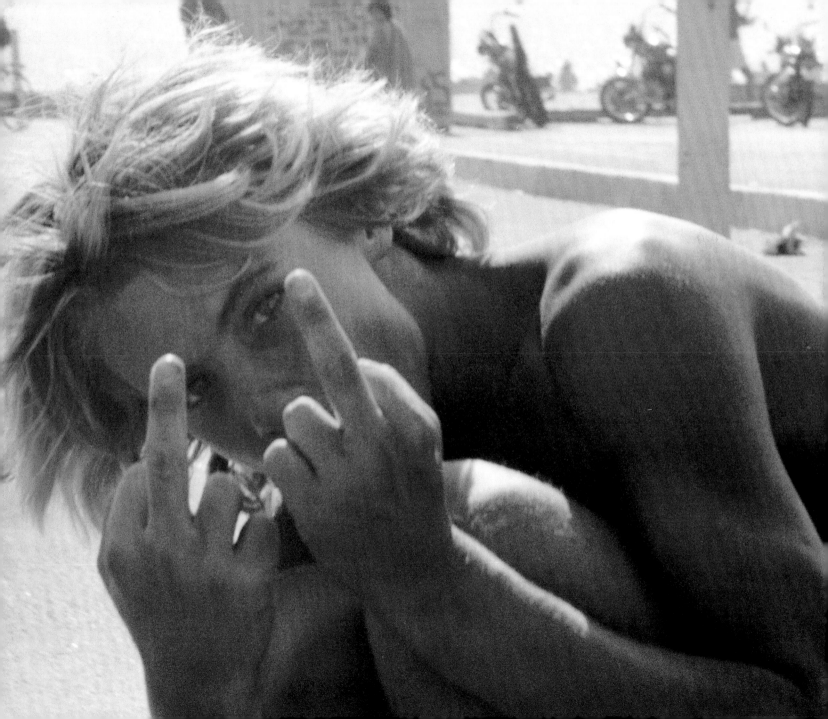

Published in the United States of America in 2017 by
UNIVERSE PUBLISHING
A division of Rizzoli International Publications, Inc.
300 Park Avenue South
New York, NY 10010
www.rizzoliusa.com

Photographs © 2017 Kent Sherwood
Introduction © C. R. Stecyk III
Captions © Jay Adams

The captions were written by Jay Adams while incarcerated at a Federal facility in 2006.

A handful of pictures shot at the fabled Paul Revere Junior High School, circa 1970, resurfaced after Jay's passing. Some have been included in this edition.

All royalties from this book are being donated to Jay's children Seven Adams, Venice Adams Vaughn, and Jay's widow, Tracy Adams.

Special thanks to Michael Early of Pool King Skateboards for all of his tireless work on this project from the beginning; and acknowledgments to Tracy Adams, Jef Hartsel, and Ozzie Ausband for their assistance with this edition.

Particular thanks to Glen E. Friedman for his curation and design of the original edition, as well as his invaluable assistance with this new edition.

Image on page 6 courtesy Kent Sherwood personal archive.

First published in 2006 by Concrete Wave Editions in coordination with Burning Flags Press.

Universe editor: Jessica Fuller
Design: Kayleigh Jankowski

2017 2018 2019 2020 2021 / 10 9 8 7 6 5 4 3 2 1
Printed in China
ISBN-13: 978-0-7893-3282-0
Library of Congress Control Number: 2016950171

BURNING
FLAGS
PRESS